THE HOUSE OF NINE SQUARES

Letters on Neoism, Psychogeography and Epistemological Trepidation

STEWART HOME
with texts by FLORIAN CRAMER

INVISIBLE BOOKS 1997

published in 1997 by
INVISIBLE BOOKS
BM INVISIBLE
LONDON
WC1N 3XX

printed by
THE BOOK FACTORY
35-37 QUEENSLAND ROAD
LONDON N7 7AH

A C-I-P record for this book is available from the British Library.

The images on the cover were sourced by Florian Cramer. They are taken from Paolo Veronese's fresco *Dialettica* (circa 1580). The cover design and lettering is by Woodrow Phoenix who also designed the INVISIBLE BOOKS logo.

Special thanks to Woodrow, also to Siôn Whellens.

ISBN 0 9521256 7 6

Introduction

What follows is structured around a sequence of letters I exchanged with Florian Cramer. We are both interested in Neoism but the rhetorical systems we have fabricated around this 'movement' are quite distinct. Naturally, this leads to a considerable amount of disagreement, with both of us modifying and sharpening our positions during the course of diverse argumentation. It should go without saying that such antagonism is necessary if the discourse that has developed around Neoism is to be kept from degeneration into a hideous caricature of itself.

I like Florian a great deal, but I am also one of his cruel critics. However, people can remain friends without agreeing on anything at all. That said, my appreciation of Florian extends well beyond an admiration for his sharp mind. Florian has a biting wit and lives what he writes in a way that illiterates will find difficult to understand. Florian and I also agree that every narrative constructed around Neoism is inaccurate and manipulative. Given the success of my own particular historicisation of Neoism as a cultural movement in the tradition of the twentieth-century avant-garde, Florian's strenuous efforts to recontextualise it as an epistemological experiment in speculation must be viewed as Herculean. Florian, whose knowledge of rhetoric is both broad and deep, is to be applauded for his success in propagating a rival version of Neoism through the House of Nine Squares web site.

In Florian's view, Neoism is a construction. The specific quality of Neoist constructs – such as 'Monty Cantsin', 'Akademgorod' or 'Neoism' – is that, rather than simply being arbitrary, they are self-contained signs and that everything done with them affects what they represent. I agree with Florian, but simultaneously insist that Neoism is no more ridiculous as a 'cultural' phenomenon than Futurism, Dadaism, Surrealism, Lettrism or Situationism. All of these 'groups' operated on the basis of speculation, aiming to create the illusion that a 'movement' that bore their name actually existed. Florian's position is not so very far removed from my own, although neither of us are likely to admit it. The 'avant-garde' has long denied its 'avant-garde' status because it does not wish to acknowledge the ebb and flow of its own discontinuous 'tradition'. I hope the selection of letters to third parties cut into this blend and clash of opinion adds productively to the general sense of disorientation and confusion.

STEWART HOME, London July 1996.

24/8/94

Dear Luther,

I'm looking forward to getting the translation of *Guy the Bore*[1] on disk. I think Luther is spreading himself around England, I notice that one of the reviewers in *ByPass* is now using the name. In fact, this Luther reviewed my book, leading people to accuse me of praising my own work under another name, something I've done in the past but it wasn't me this time. The piece I sent you last time about the Art Strike and LB from *The Idler* had a huge chunk cut out, which made it look like I was saying LB wasn't as important as the Art Strike. Here's how the missing bit fits in, the edit really distorted my views on this point:

> However, as you've probably gathered by now, it's not just professional sportsmen who get up my nose. I have an even more violent reaction to pretentious bores who think that punk rock was an art movement. To wind-up these bozos I've just written a book that uses genre theory and Hegelian dialectics to prove that the Sex Pistols didn't play punk rock. *Cranked Up Really High*, the work in question, adds insult to this injury by citing the lyrics to some of the dumbest sleaze-bag thud ever committed to vinyl. Unfortunately there wasn't room in the book to detail the pranks I've pulled on various punk rock musicians. My personal favourite took place when I spotted Adrian Borland of The Sound posing outside a rock venue. Borland was once in a seriously obscure band called Rat Poison. As far as I'm aware, this group only ever played one gig at New Malden town hall. I'd only heard of Rat Poison because Borland and I share mutual friends. The singer was obviously waiting to be recognised and when I walked over to him, he gave me a huge smile.

> 'I know you', I said before pausing dramatically, 'you was in Rat Poison!'

> Borland's jaw dropped, he'd lost his 'rock star' composure but eventually managed to blurt: 'I'm Adrian Borland, I've gone solo now but I used to be in The Sound.'

> 'Never heard of 'em mate!' I shot back before stomping off, leaving my victim completely bemused.

> Pranks of this type are the most immediately gratifying, they just happen on the spur of the moment and there is an instant pay-off. However, they don't have the resonance of something like the Art Strike [. . .]

Anyway, in the end I guess this kind of distortion isn't very important, since *The Idler* is helping to spread the LB myth. I enjoyed winding up Borland, so it's a shame this prank has never got into print, as it must be more than five years old now. I'm going to see Jamie Reid next week, so I've xeroxed the 'Rockhenge!' article to give to him.

I've still got to write to the UPA, I like the idea of a Bureau of Unitary Cosmopolitanism, but I agree with you that PM is flogging a dead horse by writing about Istvan Kantor in 1995. The funny thing about Bob Black is that as far as I know, no one has ever challenged him about the piece he wrote for the neo-Nazi *Journal of Historical Review* in 1986, there may be an innocent explanation for how his work ended up in the hands of the Institute of Historical Review but it's certainly strange that he didn't clarify this matter when the piece was reprinted in his book *Friendly Fire*. Like you, I think there's a definite contradiction in Black being involved in AASAC activities and attacking the Art Strike, although I think it was actually a productive contradiction, which as far as I know has no connection with his 'critique' of *Assault on Culture*. Kirby Olson told me Black attacks me because he sees me as his chief rival for leadership of the Anglo-American 'marginal milieu', which isn't something I actually aspire to.

Among a lot of other shit, I've been reading stuff by and about the Christian Conservative Eric Voegelin, who considers Hegel a Gnostic and Bakunin a Satanist! Voegelin attempts to insult Hegel by calling *The Phenomenology of Mind* a 'grimoire', but I think this is praise indeed! However, in the course of all this I've discovered I'm going to have to read Plotinus and probably Proclus of Athens too. I just hope I can find time to do so before the next *Re:Action* is due out. [. . .]

Ciao, Luther.

1. This text was later published under the title *Guy Debord is Really Dead* by Sabotage Editions, London 1995.

Letter 2: Florian Cramer to Stewart Home

30/8/95

Dear Stewart,

Stuck in an argument with and about 'Luther Blissett', I am dropping a line to let you know about Berndt's mention of your appreciation of *Cannibal Holocaust* which I share. Haufen recently released a CD of the admirable soundtrack. Once in my life, I would like to have the chance of producing a mock mondo-style cannibal movie loosely based on Shakespeare's *Tempest*, preferably with Jess Franco as the director and Udo Kier as Prospero (in the appearance of a 20th century South American dictator of a jungle colony). Once I even wrote a story outline.

I used up my vacation discovering Giorgio Manganelli and P'u Sun Ling's ghost stories, plus writing and working on the Seven by Nine Squares. [. . .]

So I seem to have got involved with those people you and Fabian mentioned last year. Luther Blissett's reply to my mail:

> Some of the things Cantsin wrote in her/his message are true, but as far as Luther Blissett is concerned, s/he's not well-informed. Luther Blissett is not a 'proposal', it's something real which already exists. This multiple name concept aims at superceding any preceding experience. It is no longer possible such a failure as that of Monty Cantsin etc., first of all because there is no Istvan Kantor here, the real origins of the project are hidden in a mythological dimension (i.e. urban legends concerning UK, USA and Jamaica) and are not knowable by the media and the police. Cops are going mad to know who and what the fuck is Luther Blissett, and the increasing press coverage is unbelievably contradictory. The Transmaniacs have never been regarded by the media as the launchers of the project, but only as translators of a legendary *Luther Blissett Manifesto* written by Harry Kipper (or, in an alternative tale, by Ray Johnson, and ever new details are constantly given by those who join the project). The Transmaniac collective no longer exists since 1994, and the first people who made use of the name have been supplanted by its actual propagation. As an example, I was one of the first to become Luther Blissett, and I myself am surprised at the success of the global performance. I'm unaware of many actions signed with the multiple name (mainly psychic attacks, swindles, fights with the cops . . .). And what's more, most of the 'Luther Blissetts' (urgh!) have nothing to do with 'artistic milieus' (an artistic dimension would lead to the exiguousness of the adherents, and was one of the causes of the preceding fiascos): they got to do with class war and riots, as well as with trash-pop culture, architecture, science, sociology, finance and so on. By the way, Cantsin wrote: 'There can be little doubt that Monty Cantsin remains the multiple name adopted by the largest number of people (more than 100 since 1977)'. Well, Luther is not interested in such a competition, nevertheless there can be no little doubt that people involved in *Radio Blissett*, a Rome-based weekly psychogeographical night-program broadcasted by Radio Città Futura, are more or less one hundred, and that the most recent 'psychic attack' involved 200 people claiming to be Luther Blissett. And this regards only one of the towns in which this multiple name is adopted! According to *L'Espresso*, the most important Italian information magazine, there have been actions performed by more than 400 Luther Blissetts simultaneously (see 'Giù la Maschera, Luther Blissett!', *L'Espresso*, July 14th 1995). So fucking what? It's true that Stewart Home's books are not signed 'Karen Eliot', but this doesn't prevent Luther's books (*Mind Invaders*, which will be issued

in October) being signed 'Luther Blissett', all the pieces in the *Luther Blissett* journal and elsewhere being signed Luther Blissett, all the CDs (see http://www.planet.it/voxpop.html), records, videos and radio-shows concerning Luther and his/her psychogeographical activity being signed Luther Blissett, etc. It obviously is not Cantsin's fault not to know all this: unfortunately Luther's WWW homepage (http://linux1.cisi.unito.it/luther) is still very incomplete and we got some technical problems, so what I said above can't yet be found there, but if s/he gives her/his 'physical mail' address we can then send much more material than s/he'd imagine (both Italian and English). Clearly I'm not against the use of many different aliases, for the important thing is multiplication of the identities, but the LB project is an experimental subversive urban legend which is spreading itself nicely, and I am interested in pushing it forward and further.

All the best, SALUTHER!

Needless to say that I dislike the leftist claptrap in Luther's writing. Although I am rather detached from the Neoist Alliance manifestations, these people seem somewhat unsophisticated taking them, obviously, for some pro-situ leftism. My reply to Luther Blissett:

An over-identification of Cantsin with Istvan Kantor has mainly been claimed by Stewart Home. While Home may have had a point in the mid-1980s, he has perpetuated a private war against Kantor since, and his accounts of Neoism (notably in *The Assault on Culture*) seem, beyond other questionable aspects, hilariously overshadowed by respective polemics. Since virtually all Neoists refused to write about Neoism in other than – obviously – manipulated forms, Home's historicising, by appearing 'serious' although lacking standards of scholarly criticism, significantly helped to make Neoism known to an outside public; but it also strategically reinforced one particular view of it.

In a fashion similar to Luther Blissett, Cantsin is known to surround himself with a vast body of contradictory mythologies, and there are many different narratives about his 'origin' (e.g. Monty Cantsin being derived from the Lithunian puppet player Maris Kundzins, from the Californian performer Monte Cazzaza, or from the Hungarian singer Istvan Kantor, Monty Cantsin as an allusion to Raymond Roussel's Martial Canterel, to late medieval mystics, or to Jesus Christ, or as an allusion to the 'Jesus Christus Ltd.' of the Berlin dadaists as the first 'multiple name concept', or Monty Cantsin as a reverse reaction to 'Portland Academy' member Dr. Al Ackerman's more than dozen pseudonyms etc.).

Luther Blissett wrote: 'And what's more, most of the "Luther Blissetts" (urgh!) have nothing to do with "artistic milieus"' but seemingly with the classic urban leftist ones: 'cultural terrorism, international gang of revolutionaries, mail artists, poets, performers, underground 'zines, cybernauts and squatters, effecting sabotages, hoaxes, urban legends, performances, magazines, bulletin boards and TV or radio broadcasts are spreading the name all over the world, psychogeographical warfare'.

At present, Luther Blissett may be the most 'alive' multiple name while Cantsin has tended to become rather speculative today, an endlessly aporetical emblem of an arbitrary signifier that is stable at the same time. As mentioned in Cantsin's previous post, such a signifier cannot be exhausted in 'resistance mythologies' based on clear-cut twofold epistemologies with 'the cops' and 'us'. Like in Neoism before, this might be Luther Blissett's potential to trick his perpetuators.

Cantsin.

John Berndt wrote to Luther Blissett:

What Monty Cantsin missed in her response to your news group posting is that there is no need to differentiate between using many names for one thing and one name for many things. The paradigmatic shift is the dissociation between names and things, ascending to a more refined spectrum of these dissociations which open up semantics. The contradictions so produced need to be potentiated towards the transformation of social reality, opening up the human psychology as well as the objectified realm of communication. Anything is Anything. There is no need to exclude or differentiate between them.

An often missed factoid: Neoism itself is a multiple name. 'The Neoist Alliance' was an attempt to potentiate a contradiction in 'Neoism' by the following paradox: Neoism claims not to be limited so why can't it accept a Neoism that is limited to not be Neoism. Provable unprovability is provable or else untrue.

My reply:

Yes, but the attribute specific (multitude, hence specific, hence . . .) of Cantsin is to focus the paradox of that dissociation within one (multiple . . .) signifier. By saying that 'there is no need to differentiate between using many names for one thing and one name for many things' you're caught in the paradox that you actually 'name one thing' (etc.) Therefore, Cantsin remains (a signifier [a symbol, an allegory, a signified] of) a constant problematisation of one and

11

multitude, signifier and signified, a differentiation always to be (somehow, temporarily) solved, but never dissolved. 'Anything is anything' is a paradox by the predication 'is', '"Anything is anything" is a paradox' is a paradox. Etc . . .

If there wasn't the 'dissociation paradox' (if 'anything could just be anything'), there wouldn't be the name 'Monty Cantsin'.

Cantsin.

Letter 3: Stewart Home to Florian Cramer

31/8/95

Dear Florian,

Your letter of 30/8/95 arrived just as I was about to sit down and write to you, Alastair Dickson and Luther Blissett. A few days ago, Alastair sent me a copy of the electronic communication you'd sent to him about Blissett et al. Obviously, we have different views about Neoism and various other matters, but I think your dislike of Hegelianism makes your response to Luther Blissett somewhat one-sided (Hegelianism is a tool, not something anyone with any sense actually believes in). As far as I'm concerned, Luther Blissett is easily the best multiple name to date, precisely because of the conscious use of a 'creation myth' to detach the project from those who initiated it. Again, competition on this subject is pointless, but I do think you're wrong to suggest Monty Cantsin has been more used than Karen Eliot, since Karen Eliot permeated a much wider milieu and in the late eighties regularly turned up in places such as the letters pages of *City Limits*, and still appears in the correspondence sections of everything from *Fifth Estate* to Socialist Worker Party publications (I have no idea who is responsible for most of these epistles). Luther Blissett is the name that has been the most widely used as far as I can see, although as someone using the name pointed out in the electronic exchanges with you, this isn't important. Obviously, you simply weren't aware of a lot of the Blissett usage when you sent your earlier communications, so I can understand why you made this mistake. You didn't seem very interested in the Blissett stuff I sent you last year, so I hadn't sent the more recent things I have.

It wasn't me who spread the Kantor myth, I deconstructed it and very often simply ignored it, but it turns up yet again in its unreconstructed form in the *Into the Pigs* catalogue that I just got a few days ago, reproducing Pete Scott's garbage about the subject yet again, along with more dreck from Kantor. However, if you can turn the Cantsin name around and make something good out of it, I'll be pleased to see you do it. I've never presented my texts as scholarly, and in any case this mode of discourse has it own myths and limitations, so I was somewhat mystified by your descriptions of my writing as failing to live up to the form (surely much of what we're all involved with places us in a position of opposition to academic formalities). Likewise, I didn't

use Karen Eliot as a name for my novels precisely because a multiple identity won't work if one individual does a disproportionate amount of things with it, if others had been doing as much with the name, then I might have done more too. This is exactly where Luther Blissett works very well.

As you know, I have always found your texts and comments useful in helping me develop my own thoughts, so I think it's healthy that you should be involved in debate with members of the LB project. Both parties are capable of carrying on a mutually productive dialogue and then (please excuse my left Hegelianism), forging a passage from theory to practice. One of the many failings of the Neoist Network of the eighties was the anti-art activism of its participants, which meant things were simply done rather than being thought through, resulting in an unfortunately inevitable lack of debate. As you know, I consider Neoism to have been finished by the end of 1986, but if you'd got involved a year or two before, things might have worked out very differently. By the way, I decided to quit Neoism in April '85, but went to the Ninth Neoist Festival because I'd already agreed to do so, what took place in Italy had no bearing on my decision to end my involvement with Neoism, as you erroneously suggest to Alastair Dickson.

With regard to this type of activity, there are, of course, still a lot of issues that need to be confronted. For example, the whole question of the nature of the relationship between the avant-garde and the underground; a 'common sense' view might be that the avant-garde feeds off the underground (what I've said so far seems to characterise the thinking of those individuals associated with the *American Book Review* who are promoting the notion of an 'avant-pop'). Connected to this idea is the notion that the avant-garde simultaneously attacks the underground for its lack of theoretical coherence. However, with multiple names and similar concepts we can see the whole issue from a very different perspective, since multiple identities are a means of creating a context for ideas and activities that might otherwise have no way of finding an effective social space in which to function. Since such contexts are created most effectively by those who tend toward a more 'theoretically coherent' perspective (in other words, those to whose activities it makes some sense to attach the label 'avant-garde'), it is clear that in this case, it is the avant-garde that is creating the possibility for various underground activities to take place. Of course, a lot of what has been produced under the rubric of *Smile* or Neoism is of no interest to me beyond the fact that this is the context in which it has occurred. However, I don't feel that this particular issue needs to be addressed directly. Nevertheless, I don't see my position in relation to all this as vanguardist; while I accept that some individuals have a much better grasp of the issues than others (and I would, of course, include you among them), the Luther Blissett project illustrates that these matters are resolved most effectively when undertaken by a large group that is collectively confronted with practical tasks.

I haven't yet had a chance to go through everything on the last disk you sent me. I thought the Shawn P Wilbur piece on the Art Strike was surprisingly sympathetic and a nice example of second order discourse in relation to what we've all been doing, although perhaps inevitably, I didn't feel it advanced the debate that's gone on among

those who were involved, but maybe it has among those who weren't. Enclosed with this is a disk with the typeset versions of *Smile* 11 and *The Art Strike Handbook*. They're still in Pagemaker 3 but I'm sure you'll be able to sort this out. I'm afraid I haven't got any of the earlier issues of *Smile* on disk, so that's it basically, as far as the material you asked for goes. I do have electronic versions of most of the more recent non-fiction, so if you want any of that, I can send it.

Ciao, Stewart.

Letter 4: Stewart Home to Luther Blissett

31/8/95

Dear Luther,

It's great to finally get an English translation of *Guy Debord is Really Dead*, both you and Miss Luther Blissett have done a fine job. Our plan is to make a few improvements to the text, although 99% of the work has been done, and then circulate it (probably as a pamphlet, since there's no particularly obvious place to get it printed). This may take a bit of time, as various other projects are on the boil, but it will happen eventually. The thing that struck me about the text was your criticism of that old idealist notion of vanguardism, which I must confess to not spotting the one time I read the *Veritable Split* all the way through. Strangely, Luther found Debord's criticism of Bakunin in *Society of the Spectacle* very useful when composing the soon to be published English language tract *The Sucking Pit* which, among other things, attacks the vanguardism of the anarchist 'invisible dictatorship'. Your comments on the 2nd Situationist International also hit me with great force, it's good to see these issues being turned around again. I think the text will have a good effect when we get it circulated in Anglo-American circles, since it hits Debord much harder than anything I've ever seen, there are a lot of issues which haven't been raised here which Luther deals with very well.

On other matters, I'm very happy for *Red London* to come out before *Defiant Pose* in Italy. Matthew Fuller, who Gomma was staying with in London, thinks it would be better for *Defiant Pose* to come out first, he thinks the political message is clearer in that book, but I really have no preference. Anyway, I think you'll do a first class job as translator and I've every confidence in Shake Editions as well, so once you've got a money deal sorted with them, I think everything will be swell. Luther Blissett is everywhere these days, I've just been sent snail mail copies of electronic conversations people I know in Germany and Scotland have been having about him. I enclose a copy of the letter I've just written to Monty Cantsin of the Seven by Nine Squares in Berlin, since it may be of interest to you. I got the Luther Blissett CD from Vittore Baroni. I've also been investigating Blissett Street in south east London, which is very near Greenwich Point, beneath which lies the Blackheath Cavern. According to legend, the cavern under Point Hill was carved out by Locrin, the son of Brutus, because although he married Gwendolina (daughter of the King of Cornwall), he wanted to carry on an

affair with a captured German girl called Estrildis, who he concealed in the cavern. Locrin would pretend he was going to make sacrifices to the gods whenever he went to screw Estrildis. Fabian is considering organising a procession along Blissett Street and up to Greenwich Point, we both made independent investigations and are agreed on the best route. So Luther may soon have his first proper parade in London.

Ciao, Luther.

Letter 5: Stewart Home to Nigel Ayers

3/9/95

Dear Nigel,

Thanks for sending two more Nocturnal Emissions CDs, which again I've only had the chance to listen to once before putting my fingers to the keyboard of my malfunctioning Mac Plus. Anyway, I really enjoyed both disks and also the letter from Karen Eliot to the *Cornish Guardian* of 24 August 1995. Only the other day I was telling a correspondent that Karen was still turning up in the most unlikely places. I had no idea you did the *Spanner through Ma Beatbox* flyer criticised in the *Festival of Plagiarism* pamphlet. As I get older, I just keep finding the same old faces turning up again and again like bad pennies, and it's actually quite inspiring the way a lot of the more interesting people have kept their projects going. Sometimes it seems like people I haven't pitched into in print don't have full credentials as members of the Anglo-American underground! Nice to learn that Andrew Burton of Pornosect, your collaborator at the Festival of Plagiarism, was Michael Heseltine's secretary – I'm sure there's a few conspiracy theorists around who can make a great deal out of that!

I ran into Robin Rimbaud of *Scanner* fame yesterday and we spent a couple of hours gassing about the various stupid stories going around about each of us. I met him the first night he ever tried his hand at being a DJ, which was at a party in a Camden pub when he took to the decks after my girlfriend of the time had finished her session. It was a ludicrous evening, the way the gear was set up resulted in the records jumping the minute anyone started to dance! [. . .]

Ciao, Stewart.

Letter 6: Stewart Home to tENTATIVELY, a CONVENIENCE

3/9/95

Dear tENT,

You sounded good from your letter of 13 July which got stuck at the bottom of my ever growing mail pile. I'm trying to clear through some correspondence before getting back to a book I'm working on. In the meantime, various other projects have distracted me, including a critique of anarchism, which has got to be one of the stupidest ideologies ever invented, with its apocalyptic creed openly displayed in the @ symbol (alpha and omega, the beginning and the end, in other words, just another brand of secular Christianity). Good to hear you got your new record out, seems like things are getting a bit more settled for you in Ontario. I think you misunderstand my 'fascination' with deceit, it does not follow from this that I am interested in deceiving people. By deliberately drawing attention to this factor in my writing, I try to force the reader to make a critical appraisal of the text. I'm not interested in getting people to believe things, I want to expose the way in which belief/ideology is structured. In relation to this, there are, of course, all those old philosophical chestnuts – such as 'everything I say is a lie', a statement that cannot possibly be true; what needs to be dealt with here is not the apparent content, but the way in which a paradoxical statement of this type draws our attention to the fact that language is anything but transparent.

As far as I'm concerned, it doesn't matter whether or not you consider yourself to be influenced by John Cage; in *Neoism, Plagiarism & Praxis* I deal with the fact that you operate within the same tradition or field of discourse as Cage. It is common enough for one individual to dislike the 'ideas' of another individual whose 'thought' is the product of the same social and cultural forces. Your assertion that you've 'never even read one of his (Cage's) books' has no bearing on this matter whatsoever, since I don't make any such claim and my argument doesn't require you to have done so. Besides, Cage is pretty much a side issue, the main thrust of my argument is against your *Sayings of a Famous Artist*, which I demonstrate to be a mystification of how the culture industry operates. Something I unfortunately didn't have space to deal with was your use of letter substitution and its relationship to forms of simplified spelling. You substitute, for example, the letter 'e' with the letter 'x' to denaturalise the reading experience, whereas in systems such as cut spelling, you'd find that the letter 'e' is often dropped to create an orthographic system that is easier to use and closer to the way words are pronounced. At present, I haven't really resolved how to relate the anti-functionalism of your brand of letter substitution with the issue of utopianism (and as you probably know, since the end of the Art Strike, I have quite consciously adopted an anti-utopian position). By thinking, let's set about destroying 'thought'. When dealing with 'language centred' issues we must directly address the degeneration of verbs into nouns, the active into the passive, which is precisely why I set up the Neoist Alliance and have devoted a great deal of energy to dissolving Neoism with an onslaught of negative thinking.

Ciao, Stewart.

5/9/95

Dear John,

Glad you liked the punk book and that you've safely relocated to an ex-brothel in leafy North London. Luther Blissett is confusing a lot of people, although s/he is now so huge in Italy that everyone there but the cops know what's going on [. . .] here's the latest news as it came in a letter of 24 August from Italy:

> It seems that the SISDE (i.e. the civil intelligence) is investigating Luther Blissett. Two months ago, a LB night radio-dérive in Rome led to a would-be rave on a bus, after which the cops detained and ill-treated some comrades. A week later, the cops asked Radio Città Futura the names of all the DJs and psychogeographers of *Radio Blissett*. RCF refused and threatened to make public the tapes of the show, from which it clearly results that a cop shot in the air. A few days later, *L'Espresso* issued a good article on LB [. . .] Not only the description of LB as a 'media terrorist' but also the odd references to Templarism and Alchemy excited the police curiosity. So the police phoned our publisher [. . .] They (the police) obviously are groping in the dark and puzzling their brains, how could they define and put down in the records a multiple name which anyone may use? They're accustomed to 'traditional' seriously sad propaganda (both autonomist and anarchist) and can't grasp such delightful things as Psychogeography, Transmaniacality, Neoism, Avant-Bardism etc.

Other than that, I was wondering if you knew of any connection between Ambrose Crowley II of Stourbridge and his Quaker descendants (who owned the largest iron manufacturing business in Europe in the 17th and 18th centuries, and much of Greenwich in south-east London too) and Aleister Crowley. The Greenwich Crowleys intermarried into the Ashburnham family, whose name became extinct when Lady Catherine Ashburnham died in 1953. Of course, The Great Beast claimed the sixteenth-century poet and preacher Robert Crowley as an ancestor, purely on the basis of a shared name and with no other evidence to link them, so there isn't necessarily any connection between Ambrose Crowley II and the best known occultist of our century. I am merely curious as to whether such a link can be established, even if only on a purely spurious basis. Cursory investigation has already revealed that Blissett Street, which runs off Greenwich South Street, was named after the Victorian 'philanthropist' Rev. George Blissett (who did much of the fund raising for the erection of public buildings in the notorious Ashburnham Triangle), rather than our friend Luther Blissett. I have no idea whether this has any connection with the news I heard on the radio today that Richard Chartres (as featured in *Royal Watch* columns such as 'Behind the Lodge Door' and 'Anti-Christ Unveiled', as well as LPA material) has been elected the new Bishop of London. This is another major step on Chartres' journey from Gresham Professor of Divinity to Archbishop of Canterbury!

Ciao, Stewart.

Letter 8: Stewart Home to Lynne Tillman

5/9/95

Dear Lynne,

Hope this finds you well, I seem to have got behind on my mail, so sorry for not replying before to your card of 11 July. My housing situation is still up in the air, I've just got to wait and see what happens. All sorts of things have been happening, too much to go into now. Last week I was up in Manchester visiting my sister, but mainly I've been in London. I've been spending a lot of time walking around Greenwich, Deptford and Blackheath in south-east London, as a means of researching the novel I'm working on. I don't normally work in this way but I'm changing a lot of things with this book, including writing in the first rather than the third person. Yesterday I was up at the Greenwich Local History Library in Mycenae Road, it's a very useful place not only for information on the immediate area, but also the whole of London and Kent.

I kicked off yesterday's visit by venturing along Trafalgar Road, apart from walking along the river front, it's only rarely these days that I go into East Greenwich. The charity shops are still as lousy as when I last looked at them – I found one good pair of jeans for £2.50 but with their twenty-seven inch waist, they were far too small for me. Central Greenwich chiefly caters to the tourist trade, whereas East Greenwich is much more proletarian and better suits more downmarket tastes. However, not everything is cheap, I checked out the local secondhand book and antique shop but it was far too expensive for my pocket, a nice antiquarian history of Kent in rather poor condition cost £125 (I think I'll stick to the local history library). Having cut up past Maze Hill BR station and visited the Woodlands Centre in Mycenae Road (part of a larger area known as Westcombe), I walked across the heath and into Blackheath village itself. Being a desirable upper middle-class area, there's a good charity shop but it closes early on Monday and so I wasn't able to get in. The secondhand bookshop was open, but it's very middle-brow and I couldn't find anything worth buying. Instead, I went into Pistachios for a coffee before cutting back into Greenwich through the park. I haven't brought Blackheath into my new novel yet, I'm not quite sure what I want to take from it. Of course, it was up on the heath which overlooks London that Wat Tyler camped with the men of Kent during the Peasants' Revolt, but I'm not sure if that's the type of historical detail I want to bring in. I'm just letting things work themselves out as I go along.

The absurd encounter with Will Self at Liz Young's last winter solstice turned up in a very distorted form in the *Evening Standard* of 28/7/95. The *Standard* wrongly describe this chance meeting as being at a party and outrageously claim I shook Self's hand – as you know from the letter I wrote immediately afterwards, I certainly didn't do anything as gauche as that! I haven't seen Liz for ages but when I spoke to her on the phone a week or two ago, she sounded on top form.

Ciao, Stewart.

18

Letter 9: Stewart Home to Patrick Mullins

Dear Patrick Mullins,

Some time ago the Neoist Alliance received your suggestions concerning the Preliminary Committee for the Establishment of a New Lettrist International. At the time we received your letter, I noted that you would be moving during the summer and concluded that it would be best not to respond until you were unlikely to receive my reply, since I wanted to test various theories I have been developing concerning temporality. Your proposals have, of course, been discussed by individuals active in the Neoist Alliance, the London Psychogeographical Association and Luther Blissett project.

I am of the opinion that you should set up a Bureau of Unitary Cosmopolitanism immediately, if you haven't done so already. As and when you are able to reply to this letter, those active in the Preliminary Committee will be able to give a more detailed response to your very interesting proposals. My personal opinion is that it may be a very long time indeed before we are ready to move from the Preliminary stage to the actual setting up of a new Lettrist International.

I look forward to hearing from you.

Yours sincerely, Stewart Home.

Letter 10: Stewart Home to Luther Blissett

13/9/95

Dear Luther,

It was good to hear about the Italian leaflet *The Reichstag is Burning* by 'friends of the SI'. There is so much good material around, it's crazy that these critiques of anarchism have to be made again and again. Hopefully, *The Sucking Pit* will be printed by the end of next month. Fabian has been busy with other things, including design work for money, so he hasn't had time to finish designing the pamphlet yet. I've only got a Mac Plus with a 20SC hard disk, so I don't want to slow the thing right down by attempting to install QuarkExpress on it. I learnt to use PageMaker six or seven years ago, but haven't even tried to use Quark. The solution would really be for me to get a better computer, although if I wasn't getting screen glitches, my Plus would be perfectly adequate for most of what I do, which is really just word processing.

I think a lot of what Florian Cramer at the Seven by Nine Squares does is really exceptional, so it is excellent that he is now using the LB moniker – and it would be

even better if he changed all the references to Cantsin on his Web site over to Blissett. John Berndt is also a cool guy, I thought he was very busy with his design business, so I'm pleasantly surprised to hear he's turning up on the Net as LB. I don't hear from him much these days, but then I guess it's a lot more effort printing something out, writing an address, buying a stamp and sticking something in the mail. I was thinking about going on-line but then one of my friends put me off by telling me about all the junk e-mail she gets at work. I've got enough to do without having to deal with junk e-mail from hippies who desire my presence at their parties, and try to entice me by sending long lists of everyone else they've invited (which my friend tells me is typical of what she gets). Blissett Street in Greenwich is named after Rev. George Blissett, a Victorian 'philanthropist', who raised a lot of money for the erection of public buildings in the area of Greenwich known as the Ashburnham Triangle. Finally, I wasn't surprised to see the issue of Homo Gemeinwesen coming up again in your letter, since it seems to be the answer to the whole question of 'initiation', I hope to deal with this in the next issue of *Re:Action*.

Ciao, Luther Blissett.

Letter 11: Stewart Home to Iain Sinclair

24/9/95

Dear Iain,

I'm still at the old address, the council were supposed to decant me about two months ago. They thought I'd be happy with a tower block on the IOD but I had other ideas, and having frightened them with my with skills at complaint, we seem to have reached a stand-off. I may not have got a low rise two bedroom apartment in Spitalfields, not yet anyway, but they haven't fobbed me off with a one bedroom flat in Cockroach City either. Right now, I think they're leaving me to sweat it out, there's a major structural fault with the roof, so the temporary repair isn't likely to hold out very long – and I guess they think that once the rain starts pouring in again, I'll be begging to move and will take anything. We'll see what happens, the current estate officer is a complete wanker (must be why he's lasted a lot longer than average) but despite several attempts, so far he's failed miserably in his campaign to jack me about. Hopefully, he won't be able to hold on to his job much longer, he's hated by all the tenants I know.

No problem about being unable to persuade Mike Goldmark to shoehorn me onto the Albert Hall bill. If you can scam me into winning the competition, give me a ring and let me know what to do. Otherwise, I'm sure there will be a few good reading opportunities around *Conductors of Chaos*. I'm going up to Manchester with Paul Smith on 11th October and there's one of the regular anarcho-literary bashes at the 121 in Brixton on the 25th October. I've been trying to cut back on readings, so that I can get a bit more writing done. Right now, I'm half-way through a novel provisionally entitled *Come before Christ and Murder Love*, a bit of a departure since it is written in the first person and features a lot of sex magick in key London locations, and very little

of the usual repetitious violence. I've been trying to get hold of Marc Atkins for at least a month, so when you next see him, I'd appreciate it if you could ask him to let me know how to get hold of him, since I now suspect he's moved. I have a copy of the German translation of *Defiant Pose* for him, it uses one of his Grand Lodge photographs on the jacket and looks very fine in orange tint!

Ciao, Stewart.

Letter 12: Florian Cramer to Stewart Home

2/10/95

Dear Stewart,

An objective humorist, I am not sure whether I should 'dislike Hegelianism', perhaps just Hegelian metaphysics of history. But let me plunge into my Internet postings which Alastair Dickson forwarded to you [. . .] I wrote:

> The efficacy of multiple names becomes dubious when there tend to be
> as many as 'individual' names.

The premises of my initial Luther Blissett critique were wrong indeed, since I took the Luther Blissett pamphlet for a proposal, instead of a footnote to something already established. While I am still sceptical about the 'counter-cultural' claptrap running through the Blissett writings [. . .] and the milieus pushing the concept, I have come to terms with Blissett up to the point of adopting the name myself and pasting it below my door bell. John Berndt and I decided to install a mirror of The Seven by Nine Squares where all 'Monty Cantsin' mentions will be replaced with 'Luther Blissett'.

I also agree that it wasn't a very good idea to compare and judge about Blissett, Eliot and Cantsin in terms of quantitative 'success'. However, I still see important differences in the conceptions of these three. I wrote to Blissett:

> Karen Eliot was introduced by Stewart Home in 1985 after his declared split from Neoism as a dedicated 'anti-Monty Cantsin' concept. While the Neoists who adopted the name Monty Cantsin attempted to live and explore the paradox of a persona that was one and multiple, Karen Eliot was not supposed to be a person, but only a signature: it should not be used for daily activities. Home thereby intended to avoid a multiple name being too closely identified with a specific person, which in the case of Monty Cantsin he thought was the Hungarian singer and performer Istvan Kantor.

Assuming there's nothing in this summary you wouldn't confirm, I would like to describe Monty Cantsin as a multiple identity, Karen Eliot as a multiple pen-name and,

judging from the information I have, Luther Blissett as a collective phantom. That's why I am tending to find Monty Cantsin still the most interesting [. . .]

My attitude towards Istvan is like my attitudes towards every Neoist, ambivalent. While I understand those who left Neoism sick of having him around, like most of the Montreal guys, I also see him, especially in the early years of Neoism, as a perfect 'banner'. Your objection that Istvan believes himself to be Monty Cantsin like other people believe themselves to be Napoleon or Jesus Christ actually marks his greatest strength. I find the Kantor critique in *Smile* 8 and in *The Assault on Culture* hilarious because it takes him and his utterings – which everybody knew were mostly ridiculous – so seriously. On the other hand, I was alienated by your statements about Neoism in *Kinokaze* while Istvan's were surprisingly close to what I would have said.

Our 'different views about Neoism' result from your explanation of Neoism as a 'movement in the tradition of the avant-garde, particularly Situationism and Fluxus', which seems rather accurate for your own – Neoist and Pre-Neoist – activities and fields of interest, while the smarter half of the Neoists I know, the 'mind game players' as tENT calls them, (Berndt, Ackerman, Renaud, and after all the Krononauts and tENT himself) certainly did not perceive Neoism as derived from that tradition, but as 'mad science' or 'experimental epistemology', so that your characterisation misses the point by claiming to be a global characterisation. On the other hand, I agree that Neoism is completely laughable when considered a 'movement in the tradition of the modern art avant-garde', which would both hit the nail on its most blatant shortcomings, and, being the oxymoron it is, mark the structural irony of the whole enterprise. On the next-other hand, I am always surprised by your historification again since your pre-*Smile* 8 writings clearly stress an interest in Neoism as 'experimental practical philosophy' which I share.

(One might claim that most 'avant-garde' movements were also experimenting with epistemologies, but I can hardly see this in the case of Fluxus [aside from Henry Flynt] and even less in the Debordist SI. I guess your argument is that these movements were particularly capable of 'practically' carrying out epistemological experiments, but then you make a distinction of 'theory' and 'praxis'/'base' and 'superstructure'/'signifier' and 'signified' that oddly falls behind your premises and interest in such discourses.)

But, returning to Kantor, I see the development of Neoism from a 'visible' towards an 'invisible' movement rooted in the phenomenon that third-, fourth- and fifth-generation Neoists like you, John Berndt and finally me were perhaps better writers, but much less charismatic in public appearance than him (and less charismatic than tENTATIVELY who managed to write intelligent texts anyway).

I wrote that:

> Home's historicising, by appearing 'serious' although lacking standards of scholarly criticism, significantly helped to make Neoism known to an outside public; but it also strategically reinforced one particular view of it.

22

By the mere range of topics, its rhetoric and its title, *The Assault on Culture* suggests that it is a 'history' or even a theoretical work that also has to be judged by academic standards. Apart from the rather aphoristic and polemic manner of selecting chapters and wading through them, I mainly see terminological shortcomings. While the book is supposedly about 'culture', the notion itself is not critically examined, but heuristically re-inforced in a rather feuilletonistic sense of 'the art world', manifest in such linguistic constructs as the 'cultural worker' (a word that would be all the more tautological if 'culture' would have been used in an anthropological or even 'sophisticated' Marxist sense à la Horkheimer/Adorno or Raymond Williams) serving only the purpose of replacing, hence affirming the term 'artist'. While *The Assault on Culture* may sound to the uninitiated like vulgarised Rousseau or late Taoism, *The Assault on the Art World* would have described the project better, and it would have left the terminological calamities more obviously unresolved.

You seem to have been aware of these problems when putting certain terms into quotation marks throughout the book. Although 'conserving old concepts within our critique while here and there denouncing their limits' might be doing what comes naturally, *The Assault on Culture* could have been more thrilling *and* closer to scholarly standards when departing from a theoretical groundwork which would have abandoned the necessity of using those words-in-quotation-marks (comparable to Foucault's enterprise in *The Archaeology of Knowledge*). I am sure, the resulting book, if still a 'history', would have been thoroughly different.

I see your point why you 'didn't use Karen Eliot as a name for my novels' and, regarding the rest, I can understand that things become different once they make your living. I wouldn't, truth to tell, publish a doctoral thesis as Monty Cantsin. Kantor appropriated the Cantsin identity to a point where his respective production was no longer 'anonymous', and even John distributes his Flyntian writings, which he considers 'serious', under his 'proper' name. Nevertheless, you could have published most of your non-fiction booklets and books as Karen Eliot. In the case of the 1991 *Neoist Manifestos*, the texts are even retrospectively identified as your writing while their first versions appeared under multiple names. You also seem to have given up multiple names in all your post-Art Strike pamphlets and pieces.

My narrative of your break with Neoism was mainly based on one of your letters to Graf Haufen which he reprinted in his *Smile* 63 and later in the *Neoism Now* anthology (now completely incorporated into The Seven by Nine Squares). But, reciting from memory, I apparently blurred the differentiation between your decision to quit Neoism shortly before APT 9 and Stiletto's and Horobin's prank that, to quote your text, 'served to reinforce the resolve I had made. [. . .] It was certainly embittered by the events in Ponte Nossa,' or, re-considering my text, I should have written 'speeded up' instead of 'effected' as implied in the last few words. [. . .]

Yours with total freedom, Cramer.

3/10/95

Dear Mr. Home,

In the midst of dispute, I forgot a few things I wanted to let you know about. If this letter should arrive first, consider it a postscript to what I mailed yesterday.

In an Internet newsgroup, I stumbled over the foundation manifesto of the 'New England Institute of Pataphysics', but, after corresponding with its chairman, it doesn't seem to be overly reflected and rather qualifies as college humour. The 'Internet Point Survey' got, unfortunately, the same impression of Neoism and The Seven by Nine Squares. I would have preferred any other description or misreading instead:

> [. . .] This text-heavy monument to absurdist philosophy spends a long time making a point of its pointlessness, espousing a 'Neoist' belief in using 'fraud as a revolutionary device'. What this means is anybody's guess, but it looks a lot like pranks by college kids coupled with pictograms and (intentionally) confusing hypertext. Buried deep in this mish-mash are enough serious treasures to keep you tied up a while (such as *The Gospel of Thomas* in its entirety), and plenty of amusing/aggravating descriptions of experiments in being weird for the sake of weird. 'The lies of the last two hundred years', the Neoists say, 'are nothing compared to the lies of the last two centuries'.

Of course, that quote was made up by the reviewer. This all means nevertheless that The Seven by Nine Squares are rated 'among the top 5% of Internet sites' in the most important Net survey. They also had the honour of being 'Web of the Week' in the commercial British *Flames* magazine and 'Renaissance Surf of the Day' in *HotWired*.

Your floppy disk came at the right moment as it allowed me to mail the Jorn critique to the New England pataphysicians – a critique which, upon re-reading, seems a hilarious polemic against a partially similar and therefore competing project (as Rumney says on the same page). Jorn's Marxist categorisation of the history of religions may have a point in observing a late-modern tendency towards a 'pataphysical' occult underground and establishment as obvious in currents like the Church of the SubGenius, the Discordians, the Crowleyean Satanists, the Steinerites[1] or, in a negative sense, Scientology where in Korzybskian fashion all phenomena of equality or 'false identity' are attributed to the 'reactive mind' and subsequently 'cleared'. But Jorn overlooks gnosticism and Taoism entirely; bearing just those attributes he describes as 'pataphysical', they disprove the historical linearity of his theory. (After all, Jorn's critique of 'pataphysics' may easily be turned against the SI itself.) [. . .]

In my letter, I also forgot to mention a new book, *Destruktionskunst* (Destruction Art) by Justin Hoffmann, subtitled *The Myth of Destruction in Art of the Early 1960s*, Munich: Verlag Silke Schreiber, 1995 (ISBN 3-88960-033-6 – I got a review copy, so

the book might not officially be out yet). While most of the material presented is well-known and well-researched (Fluxus, Nouveau Réalisme, SI and Vienna Actionism in detail up to a comprehensive chapter about the Yippies, Art Worker's Coalition, Kommune 1 and Provos) and the theoretical discussion is rather superficial, the book might be the first to cover Gustav Metzger's 'Auto-destructive art' in greatest detail. It has 20 pages about the three manifestos and the two lectures and another 20 pages about the London and New York symposia. The SI section heavily draws on *The Assault on Culture* and mainly serves to describe the development from the Spur group to K1 and the Baader-Meinhofs (Hoffmann seems to have difficulties making the SI itself productive for his subject). In fact, the whole chapter 'From Artistic to Political Action' (pp. 167-181) plagiarises *The Assault on Culture* while elaborating on the German and Austrian groups.

I know Hoffmann from his work as a freelance critic for *Kunstforum. Destruktionskunst* is the book adaptation of his Ph.D. thesis. It exemplifies the typical sadness of the more ambitious feuilletonistic 'art' criticism in Germany in its desire to engage in a theoretical debate all the while referring to the typical second-rate works cited in the 'art' journals, from Baudrillard to Zizek.

Cramer.

1. Cramer-speak for 'Anthroposophers'.

Letter 14: Stewart Home to Lynne Tillman

16/10/95

Dear Lynne,

Good to get your note and see Madame Realism is still going strong. Things here are pretty crazy because a whole load of stuff got piled up together, entailing eighteen hour days &c. Anyway, I'm through the worst of it now. I went to Lisa Clarke's house warming party a couple of weeks ago now, and ran into Gordon Burn. I ended up talking to him because he'd turned up with one of my friends. He'd met Liz Young a week or two before, and told me that he'd thought she was Julie Burchill when he was introduced to her. Liz was mortified when I told her, it's a pretty bizarre case of mistaken identity because she looks nothing like Burchill. The party was packed, plenty of nice people but too many blokes in cords, yuk!

Pete was on top form when I saw him at a Compendium launch for three ST authors. Other than that, I've been stayed in working most of the time, apart from going up to the Garage at Highbury Corner a couple of times. Last Thursday's *Disobey* being the last thing. Bruce Gilbert, ex-Wire, was playing with Robert and Susan from Band of Susans, which was pretty awesome. Chris Carter, ex-Throbbing Gristle, was headlining and that wasn't really to my taste. However, there were plenty of people

there who I know, including David Tibet of Current 93 and ex-Psychic TV, who never goes out, so it was good to see him bopping about.

Haven't had time for any interesting wanderings around London lately, although I'll get back to them and my work-in-progress in the next couple of weeks. I've rung Pavilion to get a copy of *The Velvet Years* but haven't got one yet, Liz has hers okay though. I'm supposed to be going to Germany, Switzerland and Austria for a three week promotional tour at the end of November, it's good that the novels are going well over there. My only real frustration at the moment is that yet again an Italian deal appears not to be panning out, I would really like to get the stuff out in Italy and it looks like *Cranked Up* stands a chance if I'm willing to let that go without an advance. We'll see . . .

Love, Stewart.

Letter 15: Stewart Home to Florian Cramer

19/10/95

Dear Stewart,

Today I sent you some German reviews and a new pamphlet, *Guy Debord is Really Dead*, by a Luther Blissett from Italy. Actually, I too have done a few things with this name recently, although it was never my intention to carry on with this type of activity in any coherent fashion after the Art Strike. I liked your categorisation of Kantor, Eliot and Blissett as a multiple identity, a multiple pen-name and a collective phantom. However, I do not share your obsession with the former, my own playful engagement with quasi-Hegelian metaphysical versions of history (and history is always reductive bunk, so don't imagine I believe any of this shit, it's been said before but BELIEF IS THE ENEMY), leads me to favour the latter. A spectre is haunting Europe, the spectre of Luther Blissett! Glad the floppy disk was useful, it would be good to have updates on the Seven by Nine Squares [. . .]

Obviously, we have different interpretations of Neoism. However, I feel you are too quick to make judgements about my texts, when they are often far less straight-forward than your statements about them indicate. I'm not really interested in defending *The Assault on Culture*, the book was written a long time ago by someone I once might have been, am certainly no longer, and who doesn't really interest me. However, I don't understand why you say that the book has 'to be judged by academic standards', since once you get past first impressions, it ought to be clear to anyone that the text isn't intended as an academic work and that it is completely pointless to judge it as such. The title might suggest a 'history or even a theoretical work' to someone unfamiliar with sixties freak culture, but the phrase is actually taken from rhetoric employed by the likes of John Sinclair of the White Panthers, and then picked up by people like Richard Neville, editor of *Oz* and author of *Playpower*. I also note that in your polemic with AD, you make extensive use of information contained in that book

about the use of multiple identities prior to the Cantsin moniker &c. Having taken on board so much of this material from *The Assault on Culture*, I'm not surprised that you don't like what's left! Your attitude is extremely healthy. From your description of the book *Destruktionskunst*, it seems that you have made much better use of the work penned by my would-be alter-ego than Herr Hoffmann. Perhaps I have been hoisted by my own petard, since it was never my intention that the more sympathetic sections of my readership should take my pronouncements on plagiarism literally – I would, of course, be very grateful for a photocopy of pages 167-181 of Justin Hoffmann's book. Thanks, perhaps, to your dislike of the Debordists, it is obvious that Herr Hoffmann is the more expert detourner. Placing a literal, indeed fixed, meaning on texts that were intended to contribute to a fluid discourse, a veritable cum culture, is a diversion indeed!

Although I find tENTATIVELY's output amusing, I don't think it is at all rigorous, as should be obvious from texts such as *Reflections on Silence*. I find the criteria you are using for the notion of charisma wilfully perverse, perhaps this is your intention. There does seem to be some correlation between what a judgmental personality-type might view as social maladjustment and how you rank Neoists in terms of charisma, but this is clearly an inversion of how these things are 'normally' judged. While I enjoy watching you make this kind of Hegelian inversion, by going against 'consensus reality' in this fashion, your assertions are actually a mirror image of who is most likely to be found charismatic by that utterly abstract category, the masses. By its very nature, the notion of charisma is socially negotiated, the quality exists in the minds of the people who perceive it, rather than it being something that is indwelling (or not) in any given individual. Judged by these criteria, and they are the ones I'm insisting on using for the purposes of this current exchange of opinions, Kantor and tENTATIVELY are not charismatic, the kind of people I meet when I go to the supermarket would go out of their way to avoid them.

Hope this finds you well, ciao, Florian.

Letter 16: Stewart Home to Fly

19/10/95

Dear Fly,

Thanks for the Zero Content tape which I enjoyed as part of my on-going Punk Rock revival. I sent you some shit ages ago, and thought I'd manage to drop you a note pretty soon after, but dredging your missive out of the mail pile, I see it's dated 19 August! I've been busy doing all the things people like me usually do, sorting out books for publication, writing, publishing some stuff and . . . trying to catch up on my correspondence. Yesterday I was running around seeing people all day. I kicked off by picking up my mail, then shaking someone down for some money I was owed. After that I made a brief trip out to the suburbs to sort some tedious business. Then it was back into the West End to meet up with a kid called Micah, so we drank some coffee

and he told me about his interest in computer encryption programmes. Micah is in town for a week and since I was doing other shit later, I took him round to see a mutual friend out in East London. Then it was back into the centre of town to meet my friend Barry Graham and his wife, who are emigrating to Phoenix, Arizona, today. Barry's wife Marina is American, Barry is Scottish, a former boxing champion who is now a writer. I arranged to meet up in front of King's Cross station, which was a mistake because Barry was late. So I'm standing there and a hooker working that beat comes up to me trying to score, then the crack dealers start walking up and down in front of me, brushing against me, because they think I'm trying to take their business. There's a lot of video camera surveillance of the street and plenty of cops around, so the pimps and pushers prefer to try psychological intimidation before resorting to physical violence. Barry was real apologetic when he showed up, because he realised I'd get that kind of hassle hanging around King's Cross after dark without so much as a business suit for protection. We went for something to eat, then Marina went back to where they were staying, so that me and Barry could talk writers' shit over cheap cups of tea, which basically means complaining about how we don't make enough money. Then I took Barry to see the Freemasons' Grand Lodge, as he'd never seen it, despite frequent visits to London. It's an impressive looking building, designed to be psychologically intimidating. So I got home sometime after midnight, a respectable time to get in.

Ciao, Stewart.

Letter 17: Stewart Home to Clemente Padin

19/10/95

Dear Clemente,

With regard to your request to participate in the Preliminary Committee for the Founding of a New Lettrist International and the other communications I received from you earlier this year . . . I epistle to hovel iconoclast titillate will come as no sacrament. Subsequently moved to ache mail trimmer mullions. Old computer to our little courtesy for the FA New Altruist. My overwhelming urge often used to travel on then, omitting marital was experiment with temper. Athena is in England net of one shilling, hell of a bullshitter, although it may perhaps not be the boniest recipe derived from your safety. A certain patented enzyme unresponsive, do not consider this rude. Anus in Georgia before I had a chance to rot. Only own a CD expansion and a British beat combo of the null and void variety. Things I've wanted to do with the blasphemously huge knockers. Own that you trolls, I have visited Atlanta in Georgia but have never been to insider streets, hence my delay in replying to enquiries. I'm whizzing out for their hit *Wad Thing*, aroused to those versed in the mystic arenas with lame and bombast circumstance. I first stop of its night jaw breaking on a tonic suit. Stranger still, I often feel as if William Burroughs' oeuvre would have been much more amusing if he'd systematically used the cut-up technique in his correspondence (particularly with regard to communications with his family, publishers and the IRS) and used

conventional narrative techniques in his novels. His failure to do so proves conclusively that neither he nor his fans are of a suitable calibre to join the Preliminary Committee. We will, of course, be publishing your submissions to the Preliminary Committee in our magazine *Afterward*, although our experiments with temporality make us unsure as to exactly when this projected journal will become available to the general public. You are, of course, welcome to participate in our activities and we welcome any input you might have. I hope you received the books I sent you.

Yours sincerely, Stewart Home.

Letter 18: Florian Cramer to Stewart Home

25/10/95

Dear Florian,

It's not just the 'criteria I am using for the notion of charisma' which are 'wilfully perverse', but of course the notion itself!

Guy the Bore has been hanging around this hard drive for some time since I caught a dead-humoured Herr 'send me the reference' Stiletto penetrating tENT's host, Laura Kikauka, with a red mini-replica of his has-beenism[1], late at night on Castorf territory[2]. At last, Berit and I were recognised as those 'sex stars' of TV fame[3], but what a waste of tax money!

While having little interest in a prolonged dispute, I thought my letter made quite clear that judging something (in that case, *The Assault on Culture*) by academic standards might, frequently, not be 'pointless', but lay the finger onto the wound, as the Germans say, i.e., point at lacks of critical rigor. Of course, being the plagiarist I am, this doesn't prevent me from fooling the subscribers of the 'Avant-Garde' mailing list (among them A Dickson) with exploiting the book at the same time!

As above, Stewart.

1. The shopping cart chair which made him known as a furniture designer.
2. The Berlin 'Volksbühne' theatre where Stewart Home's reading was to take place later that year.
3. Referring to an appearence of Florian Cramer and Berit Schuck on Stiletto's and tENTATIVELY's 'TV Hospital', a night show broadcast via an ISDN telephone line to Berlin's public access TV, in March 1994. Cramer and Schuck staged an 8-hour variation of the sleep deprivation prank played against Stewart Home at the 9th Neoist Apartment Festival, Ponte Nossa 1985 and created a minor scandal because many viewers thought there had been live sex on TV.

Letter 19: Stewart Home to Stephen Perkins

29/10/95

Dear Steve,

I'm moving out of my flat in the next couple of weeks, so you'll have to scrap the old address in Poplar and use the mail box above for the time being. Clearing out my stuff is a nightmare, finding magazines I can't even remember seeing before. Well, the archive, book and record collections are all being culled to around 50% of their current size. So much of the mail art is simply dull, bad and boring. I wonder what post-modern shit you've been reading lately? If post-moderns took their own pronouncements seriously then they'd find my interest in the 'avant-garde' perfectly legitimate, since it is highly ironic and can be read as completely 'post-modern'. Anyway, I'm bringing out the contradictions in all forms of discourse, whether occult or artistic, by concentrating on a new hybrid, the avant-bard! I really don't see how you can date the Art Strike as late, or indeed early, in the game from a 'post-modern' perspective. If post-modernists were serious about their rhetoric, they'd have to accept the complete antithesis of their positions as being every bit as valid as their own relativism – I dealt with this in *Smile* 9 or 10. As for me, I've always been more concerned with rhetoric than the avant-garde or those branches of philosophy considered acceptable by the contemporary academic establishment. You can see I haven't been out much lately, since I'm too busy clearing my flat, and as a consequence haven't been able to have a good argument with anyone. [. . .]

Ciao, Stewart.

Letter 20: Stewart Home to Patrick Mullins

3/10/95

Dear Patrick,

I'm moving, which is having some interesting effects on my investigations into temporality. Clearing my flat, I found something that I thought I'd mailed to someone a year ago, they will now receive it far too late to be of any use to them since I only got around to sending it a few days ago. Of course, many of the date specific Neoist Alliance flyers are mailed after they might as well have been thrown away as far as those with a linear conception of time are concerned – but then these buffoons have no understanding of the process of historification and the ways in which it is tied to the idea of time. However, the flyers are also given reasonable distribution in ways that someone addicted to linearity could not complain about.

Since I'm moving, I'm getting a lot of mail out of the way before everything resolves itself into utter chaos. In fact, if everything had gone according to plan, I would have

moved already – but then I don't live in a world where the guarantee that I won't die of hunger is secured at the risk of dying of boredom. A number of factors outside my control led me to decide to reply to your letter of 10 October before it had time to really mature. I felt able to do this because we had missives cross in the post other than the ones mentioned in your epistle. Hopefully, there will be a further crossing of correspondences, even if in the last instance mine was a kind of eternal return – as you probably realise, I simply mailed a further copy of my original letter to your new address. If this letter doesn't cross with one of yours, then it simply demonstrates that it requires a bit more work on my part to consciously control this process. Just be grateful that you're not the prospective member of the Preliminary Committee to whom I write straightforward replies and then cut them up at random before mailing them off!

As far as the Bureau of Unitary Cosmopolitanism goes, my position is that it should be initially set up on the same basis as the NA, LPA, AAA &c. We realised some time ago that the organisational problem could be resolved by each of us having complete control over an 'organisation' consisting of one person, we would then initiate projects and the others would become involved in these if and as they wished. Obviously, the speed with which we are proceeding with the Preliminary Committee reflects the difficulties of dealing with more complex forms of organisation in a strictly non-hierarchical fashion. Indeed, it is a banality to say that in many ways the NA and LPA are formations rather than organisations. Once you've established the BUC, it would then be possible to experiment with cell division if you wish to do so.

Ciao, Stewart.

Letter 21: Florian Cramer to Stewart Home

13/11/95

Dear Stewart,

Translating the *Stellungskrieg*[1] reviews once more nourished my prejudices against the German 'alternative'/pop cultural press and reinforced my preference for the *Frankfurter Allgemeine* feuilleton. I think these papers should pay me money since their writers seem to have spent even less time on their reviews than I did on my quick-and-dirty renderings! (See enclosed disk.)

[. . .] retrospectively, I am not satisfied with the level of discussion on 'art' the Art Strike proposal has provoked. This critique of course includes the someone I might have been six years ago and am certainly no longer. It also means that I don't agree with your view of the 'plagiarism and Art Strike movements as being far more significant than Neoism'. After all, I rather see these 'movements' as a particular discourse among people who never called themselves 'plagiarists' or 'Art Strikers' like the Neoists called themselves 'Neoists'. At least outside Britain, the vast majority of people contributing to these discourse were straight-forward mail artists (as any close look at *Yawn* or even the participant lists of the Festivals of Plagiarism reveals). They

31

neither contributed anything substantial to the debate, nor drew any significant results for themselves. I even suspect the hardcore supporters in the US, Lloyd Dunn and Stephen Perkins, to have understood the Art Strike in terms of a libertarian humanism or moralist purgatory, as is obvious in statements like 'how can you have shows when people even don't have shoes' (*20 of the Most Difficult [. . .] Questions*, Perkins) or 'the whole point is that life during the strike is going to be more creative, not less' (Dunn, *Yawn* no. 4). As much as I like Lloyd, it also seems significant that he and Perkins hosted a number of mail art shows during the Strike, one of them as a spontaneous reaction to the Gulf War, and pushed the 1992 'Decentralised Networker Congress', activities which any thorough rethinking of the issues raised by the Art Strike would have debunked as utterly mindless. Similarly, most people who could be counted as part of a 'plagiarism movement' in the late '80s seem to have taken the plagiarism debate merely as some half-accepted kind of theoretical justification of their mail art xerox collage work (or 'recycling', to quote tENTATIVELY), which again became apparent in the shows accompanying Festivals of Plagiarism, even in Glasgow. On the flip side, there are leftist pro- and post-situs like Drake Scott (editor of the Wisconsin *Smiles*), Bob Black and Neal Keating or even Matthew Fuller who saw plagiarism and the Art Strike as radical anarchist actionism without being aware of their aporetic structures. I found one of your first letters to me from 1990 in which you wrote: 'you're one of the few people interested in and also seemingly able to develop the debate raised by Art Strike, Plagiarism, Multiple Names &c. Until the beginning of 1990 this was rather frustrating because even most of those involved with this stuff seemed to miss what to me it was all about'. In fact, I don't recall many more people who go beyond mail art humanism or pro-situ leftism in their plagiarism/Art Strike support other than John Berndt, tENTATIVELY (if you couple his *Confession* with his own commentary written as EG Head), some *Variant* writers, Sadie Plant, the French novelist Jacques Abeille who defined the Art Strike as a logical paradox in *Lettre Documentaire* (reprinted in *The Art Strike Papers*, p 24) and the anonymous writer from Cambridge, Mass. whose various contributions to *Yawn* include 'Frown' in no. 29. None of them can be counted as a 'plagiarism/Art Strike movement member'. If you take Berndt, tENT and me, then you can't even put this 'movement' in opposition to, let alone succession of, Neoism. (I was pissed off reading in *Neoism, Plagiarism & Praxis* that I had been keen to claim your late *Smiles* and plagiarism/Art Strike campaigns to be Neoist because I perhaps wished 'to present the Neoists as the last possible avant-garde' [p. 199]. On the contrary, my entire involvement with Neoism, most obviously in my *Smile* issues, is about purging Neoism from all associations with so-called 'avant-gardes' and re-writing it into other fields. My interest in Neoism is certainly not about 'avant-garde', whatever that may be, but – literally speaking – about 'speculation'. You are right saying that I consider your plagiarism/Art Strike campaigns as entirely within the habitual combinatorics, incoherence and after all affirmative offsprings of Neoism [to quote your *Smile* 8, 'to leave neoism is to realise it'], hence perfectly 'Neoist'. While your implicit claim that I would consider plagiarism/Art Strike indispensable for Neoism may be an entertaining synecdochical inversion, it certainly constructs a false hierarchy. You are my best example, since you, just as any other Neoist who has tried, cannot get rid of the word 'Neoism' as the positive and negative reference point of your writing and thought since

eleven years, ten years of them being marked by your alleged break with or even 'end of' Neoism. Un jour Néoiste, toujours Néoiste.)

[. . .] Anyway, I am looking forward to meet you in Berlin and have you stay here. I hope you receive this before you leave. It's sad that Nautilus has put you right onto the pop and youth cultural track. Perhaps they don't dare to present the German novels to a critical audience with a sense of language and merely sell them as slapstick. The Roter Salon is the classic example of a bohemian hang-out (a place which is otherwise used for 'video art' displays, release parties of a 'pop cultural theory zine', political cabaret and gay techno parties) while the LiteraturWerkstatt, although in a remote Eastern district, would have been a good place for an original English reading with probably a smarter, albeit young and not overly academic audience [. . .]

As above, Cramer.

1. German title of Home's novel *Defiant Pose*.

Letter 22: Stewart Home to Lynne Tillman

20/11/95

Dear Lynne,

Moving for the first time in nine years is a crazy experience. New phone and address as above. I got John Barker to do the removal, he's had the odd story published in things like *Emergency* (a magazine Pete Ayrton used to be involved with) and *Edinburgh Review*. I've known him about ten years and he's a nice bloke. Unfortunately, despite selling loads of books and records, I had too much to fit in his huge van in one go. However, when I went back to get the rest of the stuff, the lift had broken down, so I spent a week with my things split between two places. The new flat is cool, up by Brick Lane, so very well serviced both by Indian restaurants and public transport. I don't think I'll ever cook again! I'd more or less given up anyway. I used to cook nearly every night but when my mum died, I just stopped and I've never really started again. Apart from the Indians, there are some unbelievably down market caffs round here, where you hear the stupidest conversations you can imagine. Today's example, Ali who runs the Astro Star Café on Bethnal Green Road is complaining to a customer about the road works in Roman Road. The customer tells Ali how years ago the Romans built the road and buried treasure under it, and now the treasure is being dug up because the Italians want it back. Then Ali complains about the fact that the local branch of Barclays Bank he uses has been closed because the staff are too scared to work there after three very violent robberies. The customer responds that it's been taken over by another firm who've renamed it Berklays Bank. Each time the customer responds in this fashion it takes Ali a minute or two to realise he's being wound up. It really is another planet round here. Tomorrow I'm off to do a three week promotional tour of Germany, Austria and Switzerland, then I'm supposed to be going to Sheffield the day after I get back. So as usual I go from the sublime to the ridiculous.

Ciao, Stewart.

Letter 23: Stewart Home to Graham Dunn of Bertram Books Buying Department

12/12/95

Dear Graham Dunn,

Thank you for your order and subsequent letter of 5th December. I apologise for the delay in filling your order but this was unavoidable. Sabotage Editions is not a business, the pamphlets I issue in this edition have consistently lost me small amounts of money. I publish material not to make a profit but because I want to see it in print. While I try to despatch orders as quickly as possible, sometimes other commitments cause delays. You made your order two days after I left London for a three week tour of central Europe to promote the German language translations of my novels, which do make me money. Without income from sources such as this, I would be unable to publish less commercial material and while I can understand your frustration at the delay in the despatch of your order, Sabotage Editions is not a commercial operation and it is unrealistic of you to expect me to run it as if it was a money making concern. Your order and an invoice are enclosed with this letter.

Yours sincerely, Stewart Home.

Letter 24: Stewart Home to Shane M O'Riordan

20/12/95

Dear Shane,

Your letter was waiting for me with a huge stack of other stuff when I got back from a three week tour of Germany, Switzerland and Austria to promote the German translations of my books. The tour was good in that I got plenty of press, I do well for publicity most of the places I'm published, and I made good money from doing readings most nights. The writers' union in Germany has negotiated this DM400 fee for writers doing readings, so I was getting paid about four times what I usually make from readings in England. I get a bit bored going from one town to the next and never really seeing anything of the towns I go through, but that's the way it goes. I had some time off in Switzerland, so now I know Basel where my translator lives really well. I'd only been to Geneva in the French speaking part of Switzerland before, but I like the country, the people are very friendly and honest too, I think – a lot more honest than the English anyway, it seems to be that way in a lot of countries with small populations. I did a reading in Zurich, so I got the chance to visit the site of the original Cabaret Voltaire – the Dada club – that was well cool because it looked so utterly insignificant! It was good to go to Berlin again and see some of my friends who live there, I hadn't been since just before the wall came down and I hardly recognised the place. I did a reading at a place which if you translate it into English is called the Red

Salon, it's on Rosa Luxemburg-Straße in the East, which is nice since along with Bordiga and the council communists, she was definitely one of the better Marxists of the early part of this century – I really hate Lenin and the Bolsheviks! I liked Hamburg too, I'd never been before but it is a cool city. I stayed in St. Pauli, where the local soccer team are famous for the left-wing views of their fans. The week before I went on tour, I moved flat. I'd been in the same place for nearly nine years, so I had a good clear out. I sold thousands of books and records. The new place is smaller, has the same very cheap rent and is nearer the centre of town. I know the area well, since it's only five miles from where I was living before and I've lived on this side of town for a long time now. It's great because there's a twenty-four hour bagel bakery a few minutes walk away, and loads of incredibly cheap caffs and Indian restaurants. I'm restricting myself to eating out every other night, today I had vegetable curry and a nan bread with a small side salad and it only cost £2.20, which is really cheap for England – I can work out the exchange rate for US dollars but I'm no good on the Canadian currency. One of the other good things about my tour was that I got to eat in a different restaurant every night for three weeks! Hope this finds you well and that you had a good Winter Solstice (21st December, shortest day of the year).

Ciao, Stewart.

Letter 25: Stewart Home to Avi Pitchon

22/12/95

Dear Avi,

Thanks for informing me that nothing was happening, this is what I'd assumed anyway. Yeah, if you think *Studio* is a better magazine for the interview, then I guess it's best just to wait for it to appear there, even if they are a bit slow. I've been away for three weeks promoting the German translations of my novels, nothing much is happening here – especially as it is nearly Christmas, when nothing happens except an endless round of parties. Yesterday there was a London Psychogeographical Association trip to survey the BBC TV centre in Shepherd's Bush. These trips are always fun, even though I knew the area well, it's a giggle seeing who turns up. This time three of us who know each other very well, plus one guy who'd never met any of us and who was late because his train from Manchester was delayed – but he managed to spot us as we studied the various ambiences. It was raining so we didn't expect many people, this was a smaller excursion than usual but single figures are fine – I think thirty is about the most we've ever had on a trip. We spent more time in a local café than anywhere else, since it was cold and wet. [. . .]

Ciao, Stewart.

Letter 26: Stewart Home to Fly

7/1/96

Dear Fly,

I was out on a three week tour in November/December – Germany, Switzerland and Austria. Doesn't quite equal your three months but it was hard work. A reading nearly every night, I made good money. Strange coming back to a flat I'd just moved into. So, I've spent most of the past two weeks drilling holes into walls. Now I've got up all the shelves I need, not to mention medicine cabinet, tooth brush holder, bicycle hook (so now my knackered racer hangs off the wall, making it easier to clean the hall floor), toilet roll holder &c. I even wired in a phone extension, so that I've got a phone on my desk, as well as the living room. In my old flat it was always a drag running from the Mac to the phone whenever it rung. So now this place finally feels like it's my home, all I'd managed to do before I left was some painting. I'm told that paraffin will get the shit off the sink that nothing so far has shifted, so I've gotta get some tomorrow. If that doesn't work, at least I can burn the whole fucking place down!

I'm playing the Ramones right now, so everything is cool. The message on the back of *The Dystopiation of Sobriety* immediately made me think of 'Beat on the Brat'. Something very NYC about both sets of words. Funny you should quote Hakim Bey (when I spell checked this, my dictionary suggested Haiku for Hakim, best change of name for quite a while – my Mac is very PC, it thinks the fascist propagandists Julius Evola and Savitri Devi should be Evil and Devil respectively) at the beginning of the same publication, since I review a couple of critiques of him in the new *Re:Action*. Guess it ain't so funny since you said you'd been living across the street from PLW. I look forward to seeing your costumes for three-sided football sometime. I mentioned your note to Richard Essex of the London Psychogeographical Association and we both thought it was great that you were transplanting the thing into an American context. I always think of soccer when talking about three-sided football but I guess American football with the visors and everything would be even more exciting if done in a triolectical fashion!

Hang loose, Stewart.

Letter 27: Stewart Home to Shane M O'Riordan

7/1/95

Dear Shane,

[. . .] I stuck your photo on my mantelpiece and the first thing my friend Jenny did when she came to the flat was to pick up the picture and demand to know who you were. My new flat is nearly sorted now. A friend of mine has done a portrait of me in

36

acrylics to put above the gas fire but I don't have it yet. She lives out of town and is going to drive in with the painting in a week or two, it's too big to carry on the train. Today I went to buy some pictures for other parts of the flat. Doing this is really just a matter of going out the front door because there are lots of markets near to me. I found some amazing pictures, some really kitsch or just incredibly badly proportioned. Others were actually very good but not to my taste. I found a huge painting of a Mediterranean seaside village with beautiful luminous colours in a vaguely modernist style. It was priced at £30 – this is oil on canvas and about five feet by three – and it was obvious I could have knocked this down, but it was just too conventional looking for my taste. I also found an incredible abstract monstrosity of around the same size, violent slashes of green and red with a cannabis leaf painted in glitter over the top! I kid you not, and on canvas too! In the end, I got a rather badly damaged oil on canvas city-scape and two large photographs as a job lot for £8. The photos were done by an art student and feature a very self-possessed archetypal sixties girl. Both are nude but very tasteful, the lipstick, eye-shadow and bobbed hair are really fantastic. They are real period pieces.

Ciao, Stewart.

Letter 28: Stewart Home to Barry Graham

7/1/96

Dear Barry,

Can't believe we're in '96 already. Hope things worked out with Marina, it's a big step moving across the world, bound to put a strain on things. Hope you had fun with Peter Plate, he's a fine dude. My tour went well and since then I've just been fixing up the new place, so now it feels like home. Today I've finally managed to tear myself away from doing things to the flat, to sit down and write some letters. The good thing about this is I get to listen to music at the same time, which you can't do very easily over the sound of an electric drill carving up masonry! So far, I've had the Ramones, Shampoo and Flamin' Groovies. I'm now on Warsaw – early Joy Division demos which are much better than the later stuff.

I haven't seen the *Maximum Rock'n'Roll* review yet but I look forward to it. I don't mind bad reviews, often they're a joy. However, with *Cranked Up Really High* I'm getting a little fed up with reviewers not getting the subtitle right, which is *Genre Theory and Punk Rock* not 'An Inside Account of Punk Rock', which is merely a strap-line on the cover. No reviewer has got the subtitle right yet, although some have made no mention of it rather than using the strap-line. Codex said I could have the subtitle I wanted but they wouldn't use it on the cover because it would put off 'kids' buying shrink-wrapped copies in record stores. The strap-line and quote from Wordsworth were my idea but the reviewers just don't get the meaning of the former or the irony in the latter. I'd have thought that it was obvious to anyone who'd read and understood the book that by inside I mean internal or phenomenological, since I make it

clear that I don't consider there to be a centre from which it is possible to give an 'insider' account. Either the reviewers don't understand the book or they haven't read it, since it keeps getting described as an 'insider' account, something I consider detestable! At least I have the fun of laughing at their idiocy.

Maybe one day I'll find the time to get back to writing the novel I put aside half-done when the council told me I'd got a new flat. On Tuesday I've an interview for a BBC documentary about Richard Allen and Wednesday I've a business lunch with a guy who wants me to do some stuff in Dublin. Later in the month there's the situationist conference in Manchester, my schedule isn't too punishing at the moment. Hope your gigs went well.

Ciao, Stewart.

Letter 29: Stewart Home to Marshall Anderson

7/1/96

Dear Marshall,

It was really great to get your letter and new year card. I've got behind with my mail, since I've been concentrating on getting the new place sorted. Everything is ship-shape now. What strange times we are living through. Yesterday I got the last of my blinds up and then I nipped down to Tesco on the way to visit my friend Bridget who had a difficult child birth and is in the Royal London, having nearly died. As I approached the supermarket I couldn't believe my eyes, there was a queue coming out of the shop and stretching down the street. Now I know the shops can get busy on a Saturday but this was ridiculous, in the dollar rich west I'd never heard of people queuing to get into the place where they buy their baked beans and sliced bread. Luckily, as I got near, it became apparent that the queue stretching down the street was only for lottery tickets, I got my grub in double quick time because the ordinary check-outs had been deserted in favour of lottery frenzy. I haven't bought a lottery ticket yet, the odds are pathetic and you can't study form which makes it doubly pointless. However, it would be great to be a big winner, imagine the reaction if upon being asked by the media what I was going to do with the dosh I was able to say I was putting up a bounty of a million quid payable to anyone who assassinated a member of the royal family. I don't think the press would run it, but it would be great if you could engineer a situation like that!

Well, the old Neoist thing has a life of its own. I had young Jenny Slapper round the other night looking through my Neoist archives as she gathered material for her BA dissertation on American underground publishing. I've also had this pleasant mail art character Michael Lumb in touch with questions for his post-graduate thesis too. Going through the files, I found some good shit and some bad shit. Pretty mixed but some of the good is very good indeed and there's plenty of material. AD was telling me that he showed you the Seven by Nine Squares web site when you were over in Stirling. Florian is gradually knocking that out because it has been too successful. It's

38

been listed as one of the best web sites all over the shop. The material is being randomly censored bit by bit until March 24th, when there will be none left!

You mentioned the Neoist Ho Robin briefly in your missive, whose archives you're minding, but what of him? Will he make guerrilla reappearances that are every bit as mysterious as his disappearance into boreal mists? I wonder whether your sojourn in Union Street has any connection with these archives, which I have no doubt will one day be highly coveted. I think that before this treasure trove disappears into the bowels of some museum, we ought to have one more winter song from its creator.

It would be nice to visit you in the far north in a month or two.

Ciao, Stewart.

Letter 30: Stewart Home to *Here & Now*

11/1/96

Dear *Here & Now*,

I enjoyed the latest issue, particularly the 'Feuds Corner' article. Perhaps charitably, you overlooked the psychological motivation that lies behind many of the disputes you waltzed around. After observing that 'no hip young novelist worth his smouldering two tone cover shot can afford to be without a feud on the boil', the *Evening Standard* of 28/7/95 revealed that Will Self considers me to be 'a nasty little skinhead'. There are also those outside the literary establishment who use feuds as a means of drawing attention to themselves. Like Will Self, they usually do so by attacking someone who represents everything they would like to be but are not. [Michel] Prigent […] is […] an attention seeking prat. Similar observations could be made about most of those mentioned in 'Feuds Corner'. Indeed, I would have suggested it is better not to indulge the egos of the prima donnas concerned had I not so enjoyed reading about myself! 'Shame on the egoist who thinks only of himself' – Max Stirner. Keep up the good work.

Ciao, Stewart.

Letter 31: Stewart Home to Marshall Anderson

18/1/96

Dear Marshall,

I'm just trying to dash off a note in response to your charming letter of the 10th amid all the confusion of guests coming and going. My Finnish translator Jussi came last

weekend and will be staying until Sunday, Steve Schultz arrived from Portland yesterday, he's stopping over for a month, and today three comrades of the Neoist Alliance arrive from Bologna for a week long visit. I guess the air fare to London is cheap at this time of year [. . .] Yesterday I took Jussi to Greenwich, we went up to the Observatory, the site of the Neoist Time Picnic in 1984 (I still have a photograph of us all standing on the Time Line). We also visited Greenwich Point and the Painted Hall in the Naval College. Books were bought and pie and mash consumed in Goddard's. Later, we met up with Steve at Fabian's flat on the Isle of Dogs. Veggie burgers, mash and mushroom stew was the order of the day there, along with further discussion about books.

I can't remember when I told Florian Cramer that you were more interested in mail art than Neoism, but it may have been anything up to six or seven years ago. This statement was true at one time but I'm very glad that it is no longer so. Jenny the non-N'ist and my good friend (and therefore for all practical purposes now a fully initiated N'ist), is doing an American Studies degree, so she's only interested in material from the USA. I will tell her about the DATA Archive but I think she's got enough American Neoist material now, although I know you have stuff from tENTATIVELY, Zack &c., that I don't have.

As for Ho Robin's final winter song, I can imagine him doing the odd guerrilla lecture on Neoism outside Scotland, once the time is ripe. Ho Robin might be dead, but it's always wise to remember that you can't keep a good man down! Both time and space, ongoing themes in this letter, will be crucial to understanding Ho Robin's mysterious reappearance. I'd like to come North soon but I'm not sure exactly when this will be practical. Probably March or May, I have a new book published in April so I will be busy promoting that then and I am also supposed to be going to Finland that month.

Ciao, Stewart.

Letter 32: Stewart Home to Vittore Baroni

3/2/96

Dear Vittore,

Thanks for sending the latest *AP* and xeroxing the relevant parts of *Opposizioni '80* and *No Copyright*. The latter are a very useful addition to my archives. Although obviously it is impossible for me to keep up with all the reproductions and citations of things I've been involved with, I like to have as much of it as possible. If you ever come across further copies of *Opposizioni '80*, I'd really appreciate it if you could grab one for me. Nice that Ray Johnson's letter to me is reproduced in *AP*, since it mentions two subjects of particular interest, *Smile* and Arthur C Danto. At some point I'm going to have to make a critique of the more glaring idiocies in Danto's *The Transfiguration of the Commonplace: A Philosophy of Art* (Harvard University Press, Cambridge MA 1981). I can't work out what the hell has happened to the other letters

I had from Johnson. I figure they've either been misfiled or someone I've allowed to look through my archive has ripped them off. I guess they'd be one of the more desirable items from the point of view of anyone interested in the marginal arts. I can't remember what they were about, although I do remember writing Johnson a very funny letter about inviting a neighbour into my flat after she'd locked herself out of her own pad.

I'm beginning to settle into my new place, although I'm still having trouble locating stuff, since I got rid of so much when I moved and then everything else got completely rearranged. My old flat was great in that I'd been able to organise all my books and papers on the basis of an occult memory system, which meant everything was very easy to find. Your AAA publishing project looks fantastic, I hope the selection of photos I sent for the cover and/or internal illustrations of *Assault on Culture* arrived safely. We had a really good time with the comrades from Bologna, and I think they enjoyed themselves, especially at the Neolithic sites we visited. I'm now supposed to be doing an anthology of underground material focused on the LPA, AAA, Luther Blissett &c. for Serpent's Tail, so if there is any Italian material you think I should look at let me know. Obviously, I'm going to need rough translations of stuff not in English, which can be worked up by me, but I'll worry about that a little further down the line. People won't be paid for stuff, but their material will get circulated in places it is unlikely to reach otherwise.

Ciao, Stewart.

Letter 33: Stewart Home to Florian Cramer

3/2/96

Dear Florian,

I keep hearing amusing accounts of your Internet exchanges with various people, which generally seem to propagate a very one-sided perspective on my activities. I am better known for my novels than anything else, and most of these really have very little to do with Neoism as it existed back in the eighties. However, my next novel *Slow Death*, out in the UK in April, will do a lot for Neoism, since it features a gang of socially ambitious skinheads rampaging through the London art world in search of this elusive 'avant-garde' movement. Although one of the main characters in the composition is called Karen Eliot, the majority of those reading it will not necessarily know that Neoism has nothing to do with either art or the 'avant-garde'. This is a piece of information that I have chosen to share with the bulk of the readership in only the most obtuse of fashions, thereby ensuring that any 'meaning' this work might have contained will be completely dissipated by the utterly opposed readings of it that are bound to ensue as a result of the blend and clash of opinions around our mutually destructive strategies of textual 'deception'.

AD in Stirling showed Marshall Anderson a copy of a message you e-mailed, and MA is well pleased that you consider his Festival of Non-Participation 'better' than the various Festivals of Plagiarism. However, if MA understood that you were chiefly interested in the creation of aporias, I don't think he'd feel quite so flattered. I'm sure he used the word 'better' in his letter – I haven't actually checked – but whatever term he used, it seemed a little too crude to be one of your choosing. I like this constant misrepresentation, it gives 'critics' something to get their teeth into and debate. Nevertheless, I think you are wrong to see the Festivals of Plagiarism as a continuation of the Neoist Apartment Festivals, since the first FOP in London extended over two months. There wasn't a single Neoist event in the eighties that was as extensive in terms of the completely arbitrary constructs of 'time' and 'space'.

Likewise, the placing of names on texts and other productions which were originally 'anonymous' (most of the stuff in my *Smiles* wasn't credited to anyone, not even Monty Cantsin or Karen Eliot as you seemed to assume in a letter of last year), makes an even greater aporia out of material that was produced to achieve precisely that end. Also, although divers texts were rewritten among miscellaneous parties, most of the stuff I plagiarised/detourned during the eighties, I brought in from outside the Neoist Network. While Michael Tolson[1] did the odd thing that I found useful, I tended to pick up on John Berndt's reworkings of material that had already passed through 'my' 'hands'. Incidentally, does 'Stewart Home' 'actually' exist outside the deformed 'imaginations' of various 'individuals' suffering from extremely severe forms of linguistic hallucination? Personally, I find the alleged existence of this 'individual' deeply problematic.

In re-using material that passed back and forth between Berndt and myself, I was, to use the 'situationist' terminology constructed around the notion of detournement, 'devaluing' this metaphorical 'body' of 'parturition', i.e. reinvigorating a discourse that despite its non-Hegelian 'appearance', was unquestionably proselytising in favour of 'continuous becoming'. It should go without saying that the looser nature of 'plagiarism' made that particular 'concept' more 'omnidirectional'. To return to the main 'thrust' of this 'anti-narrative', such systematic 'devaluation' is something I've consistently engaged in for many years and it seems to greatly 'annoy' you. Having said this, I think we should be clear about the 'fact' that neither Berndt, nor any other member of the Neoist Network, can 'realistically' be 'evaluated' as the main source for the corporeal aspects of my theoretico-practice. That said, I think Berndt's reworking and simultaneous critique of material in his promotional flyers for the Festival of Censorship were particularly pleasing. He picked bare the bones of the plagiarist cadaver and then did something that really fleshed out the discourse we were all engaged in. Although you personally had not joined the dance at that time, I refuse to take up the crass Bergsonian position which insists that 'time' is 'real', and will therefore refrain from making an issue of this point. To re-use a well worn slogan, belief is the enemy! It may be a digression, but after all isn't that the 'point' of the manifestations in which I have been engaged for more than a dozen years, to state that I am particularly fond of Berndt's 'Dialectical Immaterialism' and his account of the so called 'Millionth Apartment Festival'. However, I think one of the joys of eighties Neoism was how utterly mediocre much of the moil was, that's a real aporia for you!

You said in Berlin, that Neoism failed to address the question of power, and while I would agree with you about this in regard to most of those who were involved in the N'ist Network, I think any close reading of my texts reveals this as one of my central concerns. However, just as you agreed with me about the problematic nature of your use of the notion of charisma with regard to various Neoists, I must concur that the notion itself is quite useless and it was 'correct' of you to flesh out my initial critique in a letter of last year. I must apologise for not replying to your last two letters or indeed re-initiating this most occluded and occult of correspondences since my return from Germany. Please perceive the textual production that is apparently passing before your eyes at this/that 'moment' in 'time' as an honorarium for your friendship and repartee. The phantom 'time' is, of course, one of the most valued commodities in our world of collusion, and as a result I often find myself too 'busy' to write the very letters that I find most pleasure in composing. I hope you received the two small packages I've sent to you since the solstice, that bi-annual reversal of perspective in the dialectical interplay between darkness and light, was observed by one of our London fraternities with a psychogeographical excursion to Shepherd's Bush. The first package I sent contained disks inscribed with the various texts you asked me to supply in electronic form, the meat of the second was a copy of *Re:Action* 3, which was then bulked out with xeroxes of German press cuttings.

Since seeing you in Berlin, I've been doing up my new flat, that's all out of the way now. I've just got to get on with more textual production, which as you know is my chief interest. I understand from various sources that you didn't like the event in Berlin, although from what I've been told, you disliked the audience much more than the actual performance. That's fine by me, since I'm not looking for a uniform response to what I do and the things that go on around it, or indeed the people who interact with it. Hopefully, next time I'm in Berlin or you're in London, there will be less pressure on my 'time'. I really enjoyed the chat with you, Graf Haufen and Mario Mentrup in the café whose name I've forgotten. It would have been nice to have spent a few more days that way, I remember that particular afternoon as being enjoyable precisely because we weren't measuring out 'time' with coffee spoons. To anyone but a cultural conservative, 'time' is the 'enemy'!

Ciao, Stewart.

1. Birth name of leading Neoist tENTATIVELY, a cONVENIENCE.

Letter 34: Stewart Home to Patrick Mullins

3/2/96

Dear Patrick,

I noted with some amusement the remarkably similar opening sentences to your letters of 22 November and 8 January. These began, 'I've been out of town for a week' and 'I've been out of town for the past few weeks'. In fact, when the first epistle arrived

here, I was away on a three week tour of Germany, Austria and Switzerland to promote the German translations of my novels. I would have liked it if you'd published my Xexoxial offering with a false history. It was done at the request of Xexoxial sometime in the late-eighties but for whatever reason, probably they just didn't like it, the thing was never published. However, Xexoxial threatened to publish the 'bookwork' during the Art Strike as 'proof' that I'd been scabbing, although as far as I know, they never carried out this threat. I don't think I have a copy of the proposed publication anymore. Rather than ending up in an archive, if it isn't published with a false history and attribution, I'd prefer it if this work was destroyed. From what I recall of it, it would be much more interesting as a lost work, rather than an item in some archive. The distorted maps of London make it unambiguously psychogeographical in content.

I thought your observations on the relationship between 'science' and the 'occult' were very suggestive. I think it would be useful if you published a newsletter containing material of this type, alongside various psychogeographical observations about your immediate environment. I think this would be a very useful function for the Bureau of Unitary Cosmopolitanism. Are you familiar with *Manchester Area Psychogeographic*, *Escape from Gravity* or *Decadent Action*? These newsletters are simply a small part of a mushrooming culture of resistance. Before you wrote, we were already planning a journal *Afterw(x)rd* to co-ordinate the activities of the Preliminary Committee for a New Lettrist International. Members of the APB were over from Bologna a couple of weeks ago but unfortunately our meeting to discuss Preliminary Committee activities was disrupted by an agitated tourist who turned up despite the fact attendance was supposed to be by invitation only. The joint NA, LPA & APB visit to various Neolithic sites a few days later was great fun, since details of the excursion were kept a closely guarded secret from the agitated traveller whose macho fascination with 'extremism' transformed him into the butt of many jokes. Over to you . . .

Stewart.

Letter 35: Stewart Home to Ralph Rumney

4/2/96

Dear Ralph,

I was hoping I might see you in Manchester, although I must confess that I wasn't at all surprised by your non-appearance. I was amused by the text of yours that was read out. Unfortunately, despite requesting a xerox from the organisers, both Richard Essex and myself were unable to obtain a copy. Richard Essex would like to make a public response to the text, while I would like to go through it more thoroughly. Therefore we would both be very grateful if you could send me a copy of it. We were, of course, delighted that you ritually denounced ley-lines in this document. Just as we desired, many of those present took this to be a direct attack upon us. Asger Jorn observed somewhere that the 'avant-garde' never sees its progeny, since it advances through

contradiction. It ought to go without saying that it would be disastrous for us if you were seen to publicly endorse our activities. We understand that the London Psychogeographical Association has a reputation as an occult group in France. This type of misunderstanding makes it much easier for us to realise our real aim of turning the bourgeoisie's weapons back against them. I'm sure you're familiar with the ways in which the intelligence services of various countries use the occult for propaganda and other purposes. The allies' use of these techniques are well documented in Ellic Howe's books *Astrology and Psychological Warfare during World War II* and *The Black Game*. Given your interests, I assume you've read Howe.

Right now there is an explosion of 'psychogeographical' and related activity in England and Italy, while this type of theoretico-practice is just beginning to take off in Germany, somewhere the SI never had much influence during its life-time despite the notoriety of Spur. Edition Nautilus in Hamburg, who have been translating SI texts for twenty years, but alas with no visible effect and very poor sales, have done a lot better with my novels. As a result, I have particularly good contacts with groups in Berlin and Bavaria. The Italian Luther Blissett book on psychic warfare sold out within a month of publication and Castelvecchi have had to reprint it thanks to popular demand. There are groups all over Italy and you wouldn't believe the amount of press coverage. Have you seen the account of the action against the Venice Biennale issued under the title *Ralph Rumney's Revenge*? Likewise, are you familiar with Decadent Action, the Association of Autonomous Astronauts or Manchester Area Psychogeographic? I can send you some material if you haven't already seen it.

Ciao, Stewart.

Letter 36: Stewart Home to Roger Cottrell

5/2/96

Dear Roger,

[. . .] I must confess that I found the section of your last letter, where you rail about 'Romanticist Revolt against Enlightenment Rationalism', extremely reductive. If you have not done so already, I suggest you read Adorno and Horkheimer's *Dialectic of Enlightenment* before proceeding with the project you propose. These days, even members of the scientific establishment would find the opposition you posit between romanticist revolt and enlightenment rationalism a rather eccentric position. For example, Stephen Toulmin in *Cosmopolis: The Hidden Agenda of Modernity* (Free Press, New York 1990) has the following to say on page 148:

> As a 19th-century position, romanticism never broke with rationalism:
> rather, it was rationalism's mirror-image. Descartes exalted a capacity
> for formal rationality and logical calculation as the supremely 'mental'
> thing in human nature, at the expense of emotional experience, which
> is a regrettable by-product of our bodily natures. From Wordsworth or

45

Goethe on, romantic poets and novelists tilted the other way, human life that is ruled by calculative reason alone is scarcely worth living, and nobility attaches to a readiness to surrender to the experience of deep emotions. This is not a position that transcends 17th-century dualism: rather, it accepts dualism, but votes for the opposite side of every dichotomy.

It should go without saying that I view fascism and the new age in much the same way, they do not represent a 'revolt' against the enlightenment but are products of it. Therefore, I could not possibly collaborate on the project you mention in the manner you currently conceive of it. I hope you find this criticism useful, if it sounds harsh this is simply because I feel I must state my own position forcefully to make it clear. If you re-read the material I've already sent you, I think you'll see clearly enough that like Richard Essex of Unpopular Books, I'm interested in superseding both the enlightenment and its irrationalist progeny.

Ciao, Stewart.

Letter 37: Stewart Home to Roger Cottrell

17/2/96

Dear Roger,

[. . .] you took the last letter well. I found your cheery comments about being a real Marxist very funny. However, I do think the International Communist Current or International Communist Party etcetera might take you up on this, and I certainly wouldn't question their right to call themselves Marxists. I certainly find the ICC's knowledge of the collected works of Marx impressive, even if I don't always agree with their opinions. The reason I mentioned *Dialectic of Enlightenment* in my last letter was precisely because I thought you'd place more weight on the views of two Frankfurt school Marxists than the opinions of empiricists or post-modernists. I don't see why being a Marxist necessarily leads someone to defend the enlightenment, since while the enlightenment might be considered historically progressive, for Marxists history does not stand still and while the bourgeois revolution was indeed a revolution in the period of capital's historical ascendancy, the social forms and philosophies it created now serve the cause of reaction. Personally, although I view Islam as being historically progressive up to the time of the Renaissance, I certainly would not wish to defend it without reservation in its current manifestations.

Ciao, Stewart.

Letter 38: Florian Cramer to Stewart Home

24/2/96

Dear Home,

Many complain that the words of the wise are always merely parables and of no use in daily life, which is the only life we have.

Concerning this a man once said: 'Why such reluctance? If you only followed the parables you yourselves would become parables and with that rid of all your daily cares'. Another said: 'I bet that is also a parable'. The first said: 'You have won'.

The second said: 'But unfortunately only in parable'.

The first said: 'No, in reality: in parable you have lost'.

Cramer.

Letter 39: Stewart Home to Florian Cramer

19/3/96

Dear Florian,

I keep forgetting what I've already written to you, I could check because all those letters have been saved electronically but then I'm not afraid of repetition. I'm going to see Marshall Anderson in the far north of Scotland in a few days. MA in his persona of the eighties certainly saw Neoism as an art movement, and he wasn't the only one. I'm probably repeating myself but isn't that exactly what parables do, reduce experience to cliché and all for the benefit of power. Parables are ways of transmitting common sense notions of knowledge and 'reality' and thus always serve the interests of the dominant classes. Their paradoxical nature is merely that, paradoxical, because power must camouflage its operation to maximise its effectiveness.. But like I've said elsewhere, I've been addressing the issue of power for a long time. I was in Brighton the other week to do a lecture for the Zap Live Art Festival. Kantor was there two years ago, this time people got a much better version of Neoism. I got a lot of laughs, especially when I showed a slide of Kantor and described him as an idiot. I did a lecture on my self-promotion techniques at the Royal College of Art the week before that and at the end was asked by a student if I'd considered teaching business studies. I was flattered. I've got myself a better Mac, Fabian's old SE/30 with 8 megs and 120SC. So now I can deal satisfactorily with some of the disks you've sent in the past. Okay, that's all for now.

Ciao, Stewart.

14/3/96

Dear Home,

Given our latest dispute, my role as *Analecta's* digital nurse is not without irony. In turn, you receive the first *Smile* issue written by a computer program plus a Neoast[1] choice anthology which I collected and typeset some months ago but never released due to financial calamity. The disk includes another Neoast collection which overcomes some Web-site disadvantages, such as titles, signatures, the given 'hypertext' embedding and limited cross-platform portability. One might consider it the bankrupt's estate of The Seven by Nine Squares, but it contains both more and less material. Finally, there's some water on your mills of historification – everything I could find about the MacMag (Brandow/Barnoz) virus in the Internet.

You're right assuming that I didn't use the word 'better' to qualify the Festival of Non-Participation against the Festivals of Plagiarism:

> Hi, I just thought I'd mention that I'd the artist formerly known as Pete Horobin staying here last week and he was well impressed by The 7 x 9 Squares pages, perhaps in a kind of bemused way at the thoroughness of the cross-indexing, etc., but impressed nonetheless.
>
> Alastair.

My reply:

> The 7 x 9 are partly indebted to Horobin's Data Project, but I never wrote him about their existence. He might have been surprised to find his own index page, if he found it at all. Stewart Home told me about Anderson's present obsession with British Mail Art, supposedly coupled with thorough disinterest in his Neoist past. While not agreeing with everything he wrote and conceptualised, I think of Horobin as one of the 'central marginals' whose contributions were more thorough than those tactically adapted according to the expectations of a certain uncritical audience. I also agree with the person formerly known as tENTATIVELY, a cONVENIENCE that the Festivals of Non-Participation were much more interesting than the so-called Festivals of Plagiarism.

Regarding your defence of using/not using the name Stewart Home, I can only say that personally, I find the alleged existence of the individual 'Stewart Home' just as uninteresting as that of 'Florian Cramer', 'John Berndt' or whomever else – at least irrelevant enough to find any construction of aporias with/against these names utterly futile. After all, such aporias seem to function as re-valuations rather than those de-valuations you claim for yourself – although their object is obviously different.

48

I actually disliked your performance, not the audience which seemed critically intelligent. My derogatory remarks however were aimed at your local followership, those 'Neoists' safely recruited from the most idiotic cabal of Berlin, yeah, 'underground' [. . .]

Cramer.

1. A variant spelling of Neoist favoured by John Berndt and tENTATIVELY, a cONVENIENCE.

Letter 41: Stewart Home to Florian Cramer

29/3/96

Dear Florian,

Thanks for the disk and the *Smile Auto-Plagiarism*. I've gone through the Neoast selection, which amused me greatly [. . .] Actually, I don't think we're in dispute at all, our positions seem to be very close. For example, you talk about your disinterest in the alleged existence of 'Florian Cramer', I share this attitude since I know very well that the alleged 'Cramer' is simply a fiction, or more precisely a minor character who appears in the novel *Slow Death* between pages 233-5. The book is published next month by Serpent's Tail. Likewise, since 'Stewart Home' is by your own admission only alleged to exist, it certainly is aporetic to talk of 'his' 'involuntary and apparently unaware self-demolition'. Of course, if such a thing could take place, it would be infinitely preferable to voluntary self-demolition, which would be masochism. Your distinction between a critically intelligent audience and the idiotic cabal of the Berlin underground seems to echo the distinction the alleged 'individual' 'Hegel' makes between critics and the public in the introduction to 'his' *Phenomenology*. It would seem that our positions are closer than either of us might imagine if we were able to constitute ourselves as that pathetic abstraction, a bourgeois-centred subject.

If you have electronically saved your letters to me, I would very much appreciate copies of them on disk. Last weekend I visited the alleged individual known as 'Marshall Anderson'. He is living in the far north-west of Scotland with Lotte Glob, daughter of PV Glob, author of *The Bog People* and friend of the Cobra group. These days, Anderson seems very interested in Neoism, much more so than mail art. This is certainly a turn around from a year or two ago. We did a little hill walking and a lot of talking. I had a fine time, staying in a very remote bothy on 24 March.

Ciao, Stewart.

Letter 42: Stewart Home to Roger Cottrell

3/4/96

Dear Roger Cottrell,

You are taking the piss. I am extremely annoyed with you for writing to Serpent's Tail saying that I 'strongly recommended' that you contact them. Since I saved a copy, I can quote you in full the passage from my letter of 17 February where I specifically asked you not to mention my name if you approached Serpent's Tail with one of your books:

> Serpent's Tail haven't expressed any interest in you whatsoever. I did mention you to them and didn't get any reaction at all, not an unusual response from a publisher. So don't fuck up by assuming they'll do one of your books. If you want to submit a synopsis of a book to Serpent's Tail, go ahead but please don't mention me, since I don't think your stuff is quite right for them as it stands (although it is always possible I'm wrong about this). A big problem that ST would probably have with your novels is length, the longer a book is, the more it costs to print and therefore the less likely it is to be picked up if it is by an author who isn't an established name. Certainly, ST seem to prefer shorter works [. . .] Sorry to sound tough but I really have trouble making myself clear to some people. Although I may be being unfair in taking this line with you, I think it is better than being misunderstood.

You know very well that I did not want to be dragged into any dealings you may have with Serpent's Tail. Since you have done this despite knowing exactly where I stood on the matter, I feel fully justified in drawing this situation to the attention of the company, and I can assure you that they will not be impressed by your behaviour.

Yours sincerely, Stewart Home.

Letter 43: Stewart Home to Marshall Anderson

3/4/96

Dear Marshall,

[. . .] I was sorry to hear your walking expedition didn't go as well as might be hoped. Well, I trust that your spirits have picked up since you wrote. I was impressed by your current set-up, although obviously it is a hard life in the far north. My trip down to Inverness was pleasant, sunny and nice scenery. It didn't take me long to view the city and then visit all the charity shops. As you'd warned me, the big secondhand bookshop

was overpriced. I found a smaller one in the Victorian market but there wasn't much in it. On the outskirts of town, I found the site of another secondhand bookshop, all that remained was the name above the window, since it had closed down. Inverness came across as a worse tourist trap than the West End of London, the PR people at the Scottish Tourist board who invented the Loch Ness Monster baloney in the early thirties have a lot to answer for. The two meals I ate were very bad, but I found a youth hostel that was okay, so the overnight stay turned out to be cheap. Having nothing better to do in the evening, I went to see *Trainspotting*. The juvenile concerns obviously weren't going to interest me, nothing is more boring than drugs. The 'British' love failure, so a film about losers can't really do any wrong in a provincial cinema. The mainly teenage audience roared with laughter, what they found funniest indicated that the general level of social and sexual repression in the Highlands is much worse than in London. An interesting 'sociological' experience, can't say I'd recommend the film. I spent a fair amount of time in the local library which has a reasonable Scottish history section. Nevertheless, Durness pissed all over Inverness.

Back here in London, I've mainly been doing administrative shit. Must get back down to some fiction writing. Apart from a lot of letters, all I managed last week was a comic strip and some CD sleeve notes. Recent business meetings have included one about scripting porn videos, I've come up with a few plot outlines since then. Nevertheless, it is harder to make money out of skin flicks than most people imagine, at least if you're the writer [. . .]

Ciao, Stewart.

Letter 44: Stewart Home to The League of Egoists

3/4/96

Dear League Of Egoists,

Modesty has never been one of my failings. I've always enjoyed Stirner precisely because *The Ego and Its Own* leads to a complete aporia. Why would anyone want to present the case for individualism, to argue for oneself in such intransigent terms is pointless, one simply gets on and does what one wants. I've always read philosophy, whether it be Plato or Hegel, as humour. While Kant's work is a little grating when read in this fashion, Stirner is side-splitting. I read *Egoism Rules* in the same spirit. As such, it would be pointless for me to express my disagreements with you, such a response would be far too coherent [. . .]

Stewart Home.

51

Letter 45: Stewart Home to *Headpress*

Dear David & David,

I'm afraid you've been duped by some sad pervert. The letter credited to Stewart Home in *Headpress* 11 wasn't written by me. It seems that a lot of people have taken to signing texts in my name, but I'm not responsible for any of the articles in the *Smile* magazine issued by Academy 23, or a number of other items that have been credited to me. If you think about it, you'll realise that I couldn't possible have written a letter claiming that I wank over pictures of female models in mail order catalogues, since as anyone who knows me will confirm, I only wank over seeing my own name in print. In fact, this has caused me a bit of a problem, since I was banking on having a mint run of *Headpress* to sell off to some collector to see me through my dotage. Unfortunately, what with the fake letter and the review of my book *Cranked Up Really High* both being in the same issue, my copy has become somewhat sticky. *Headpress* is so popular that it has sold out in all the London shops, so I have been unable to replace my badly stained edition. Therefore, I would appreciate it if you could mail me, in a plain brown wrapper please, a fresh copy of issue 11 to make up for the way in which the fake letter you inadvertently published has damaged my reputation.

Yours sincerely, Stewart Home.

Letter 46 : Florian Cramer to Stewart Home

Dear 'Stewart',

Regarding our 'valuation' and use of certain names, let me just resort to the wisdom of my mailbox:

> [. . .] Mr. Home, I don't know if 'Stewart Home' is a pseudonym or not but if it is not then I just wanted to share with you the fact that there exists a school in Kentucky which is called 'Stewart Home School'. This school is for mentally retarded children and adults. Just wanted to share this with you but I think you already knew.

> Thank you for your time, Karen.

A conceit or a Hegelian synthesis? [. . .] Luther Blissett's material about the Mondadori controversy arrived today. As if to provoke my mixed happiness, he describes the dissolved Seven by Nine Squares as:

[. . .] one of the most interesting sites dedicated to relations between 'avant-garde' and 'counter-culture' (multiple names, 'psychic warfare', conspiration aesthetics) and in full scope: Monty Cantsin/Luther Blissett, founder and Web master of the site, who tells that he is so indifferent and bored of it that he decided to eliminate one link per day up to its complete dissolution on March 24, 1996. His *Proclamation of Self-Destruction* contains the phrase: 'While everyone is trying to get on the Internet, I'm doing my best to get off'.

The above is 'my' translation from Luther's Italian. Nevertheless, 'my' text carefully avoided the word 'destruction' and was 'actually' titled *The Seven by Nine Squares Dissolve*. The sentence, which Blissett 'quotes' in 'original' English, read 'While everyone else tries their best to get on the Internet, The Seven by Nine Squares will be the first trying hard to get off!' The quote was part of Castelvecchi-Blissett's apology of non-Internet 'counter-cultural' networking against the Internet hype in Mondadori-Blissett's *Net.gener@tion*.

Ironically, I was contacted by a journalist of the *Panorama* news weekly – which itself is published by Mondadori/Berlusconi – without knowing about the *Net.gener@tion* controversy. As a result, *Panorama* printed a Luther Blissett feature on March 28 with some 7 x 9 references. The article mentions Vittore Baroni and Fabrizio Giuliani as the men behind the name, stating that:

> [. . .] he [Blissett] is indebted to ironical journals from the Anglo-Saxon world like *Smile*, *Yawn* and *TARP*. Blissett is [also] a pseudonym of the German Monty Cantsin collective and its 'Neoist' philosophy which just undergoes its negative phase: Every day, they are cancelling parts of their Web site. It will be finished on March 24th. In Italy, 'situationism' and marginal philosophers like Giorgio Agamben prevail. But generally, all the schools and orders collaborate. The entire information published by Blissett is gigantic, his hypertext is labyrinthine. Those who wish to know who Blissett is are prompted with the on-line response 'a pseudonym of Monty Cantsin'. And for those who wish to know who Cantsin is: 'a pseudonym of Luther Blissett'.

In all those twists and turns, it particularly amuses me that an Italian writer wouldn't recognise two classics of 16th and 17th century Italian literature[1] and attribute them/*TARP* plainly to the *Smile* tradition! The rest is on disk.

Best, 'Cramer'.

1. Giacomo Pontormo's Diary and Emanuele Tesauro's *Il Cannocchiale Aristotelico*.

Letter 47: Stewart Home to Florian Cramer

29/4/96

Dear 'Florian',

Thanks for your letter, disk and other material. The message was very funny, as was re-reading some of your letters. I'd misplaced the 'original' of the letter advising the spread of a false rumour that I had some nazi involvement to create interest in my novels and boost sales. A very solid piece of advice and it is good to have it to hand again. As you probably guessed, I am quite likely to nudge a selection of these letters into print in the not too distant future. I've only kept copies of my letters to you since last autumn because I think it is important to give certain documents the opportunity to be lost.

[. . .] I think both Luther Blissett and 'Stewart Home' are completely uncontrollable by any clique, one can nudge them in different directions but there is no possibility of the milieu from which they emerged exercising much influence over them now that they've entered the 'spectacle'. I think everything is working out very well for all of us.

Ciao, Stewart.

Letter 48: Stewart Home to Bob Dickinson

29/4/96

Dear Bob,

Thanks for the disk and your letter which arrived safely a couple of weeks ago. The anthology is coming together slowly but I think it will be good. Nothing particularly exciting to report, recent psychogeographical excursions to Greenwich, Brighton, Mortlake &c., were mainly executed for the amusement of my companions. Having abstained from intoxicating drugs and fluids, I hadn't defamiliarised the terrain sufficiently to throw up anything very new about these sites. At Mortlake, some fascist twerp keeps pasting up International Third Position and Final Conflict posters on the river frontage of John Dee's former property. Next time I go I must remember to take a knife so that I can scrape the offending items off a little more effectively. Have made some interesting field trips to Suffolk recently. Last one took in Orford, Sutton Hoo and Woodbridge. Managed to miss the guided tour at Sutton Hoo and just wandered around the burial site. The people running it said that legally we weren't allowed on the property but they wouldn't do anything to stop us trespassing because they were closing up. The people in charge said there was nothing to see and we should come back the following weekend for a guided tour. The meeting point for tours is a good five minutes walk away and out of sight of the mounds. The tourists must be fleeced before they discover there is 'nothing to see'. Anyway, Carolyn and I thought the

ambience was very fine. The Glasgow levitation was run by the DADAnarchists, the counter-demonstration by the Glasgow Association of Autonomous Astronauts, the same people run both organisations. They seem to be having fun [. . .]

Ciao, Stewart.

Letter 49: Florian Cramer to Stewart Home

6/5/96

Dear 'Home',

I guess you already received 'Texas Hick', the open letter, attacking, oddly enough, your *Assault on Culture* and your picks at Greil Marcus [. . .] My comment from an e-mail to John Berndt (and by cc. to 'Hick'):

> [. . .] I received that pamphlet, too, from its author. Not much to say about it really. While it started off in a promising way by addressing the 'technical' flaws in Home's book, it became laughable when turning into a Greil Marcus apology [. . .] My contribution to the 'Literature & Internet' conference/festival was, apparently, such a success that I must be careful not to start believing that I could be the 'literature critic and Internet expert' [. . .] I am now being dubbed in the media! [. . .]

At the congress mentioned, I stumbled over two people who are about to meet you in London – Mark Amerika and Mario Mentrup. While I can't tell much about Amerika and his *Alt-X* zine, I must correct my arrogance towards Mentrup. He is a nice guy – full stop. [. . .]

As always, 'Cramer'.

Letter 50: Stewart Home to Kirsty Ogg

19/5/96

Dear Kirsty,

Thank you for your letter of 9/5/96. I look forward to seeing the book you are currently preparing on the history of Transmission Gallery. As you probably know, I am very interested in the process of historicisation. Since this is inevitably a question of simplifying what actually happened, what interests me is what is excluded. It may seem superfluous to state that I am listening to *Document Series Presents Mitch Ryder*

and The Detroit Wheels as I type this letter, but this is precisely the sort of detail that tends to get lost when scholars set out to 'reconstruct' the past.

Something else that often gets overlooked by historians bent on 'radical simplification', is the friendship networks that surround any institution. I don't think it is unfair to call Transmission an institution now that you're preparing a book on its history. However, I will leave the construction of a 'family tree' of sexual liaisons between those involved with the gallery to someone who was at the epicentre of events in Glasgow. Likewise, I will not make detailed comments about the way the gallery has provided accommodation addresses for diverse groups, but I do think it worth noting that the magazine *Here & Now* has been issued from 28 King Street for some years now.

Please consider these brief comments my one page contribution to your publication. I appreciate being given the chance to express an opinion on the gallery and its history. By way of conclusion, I'd just like to say that I enjoyed working with Jayne Taylor, Malcolm Dickson, Carole Rhodes, Billy Clark, Gillian Steel and many others, when the gallery provided me with more than one opportunity to do my thing back in the late eighties. This was at a time when few others were prepared to take such a risk. I enclose with this a few newsletters which may or may not be of interest. 'Sock It to Me Baby' is blasting out as I sign off.

Ciao, Stewart Home.

Letter 51: Stewart Home to Florian Cramer

19/5/96

Dear Florian,

If the Texas Hick piece you refer to is *The Assault on Greil Marcus*, then I think it was very disappointing since it only lends Home credibility to be attacked so stupidly. If it was something else, could you please send it. With this I enclose some of the worse reviews of *Slow Death*. I won't send you the one from the *New Statesman*, where the reviewer understands that Neoism was a genuine 'movement', let me know if you really want to see it, but be warned it is likely to depress you.

My own thinking on Home is as follows:

Stewart Home became a Neoist in 1984. He puts emphasis on the fact that he split from Neoism in 1985 (after a sleep-deprivation prank had been played on him during the 9th Neoist Apartment Festival in Ponte Nossa, Italy) and that his 'Neoist Alliance', which consists solely of himself, has 'nothing whatsoever to do with the old Neoist network'.

From 1984 to 1985, Stewart Home's influence on Neoism was healthy as he reinforced the concept of Monty Cantsin as a multiple name and added those of *Smile* magazine and White Colours.

His subsequent activities, the plagiarism and Art Strike campaigns from 1985 to 1989, were marked by his attempt to find a broader audience. I will enclose additional material concerning my opinion about this. I see his 1990s activities and publications as signifiers of an admirable intellectual decline. While many of his former friends and collaborators have been critical about his blatantly self-serving and ideologically simplified campaigns in the late 1980s but at least acknowledged that these partly raised interesting debates, we all see the Stewart Home of 1995/96 as a willingly stupefied, pale caricature of himself. Consequently, his present supporters – or rather, admirers – come from lowbrow pop cultural 'underground' milieus in Italy and Germany. Being no longer pressed to define his position in negative terms, he has managed to appropriate the brand 'Neoism' for his own activities and sell this discourse at the same level as, say, the Discordians (with himself as RA Wilson), the Immediatists (with himself as Hakim Bey), the Church of SubGenius (with himself as Ivan Stang) or the pro-situ anarchists (with himself as Bob Black). Ultimately, Neoists are not interested in Wilson, Bey, Stang or Black.

With Home being skilled rather in sloganeering than versatile perception, his activities always benefited from unobvious collaboration with friends who remained in the background. In the early 1980s, this was a philosophy student who had probably inspired Home's early *Smile* issue to reinvigorate Neoism as 'practical philosophy', and in the case of the Festival of Plagiarism activities, it was Ed Baxter who made the most lucid and profound contribution to Home's *Plagiarism* reader. The 'Neoist Alliance' as an occult order was inspired both by my own pre-1993 publications and letters (the essay 'Reading for Immortality' which likened Neoism and Neo-Platonism, letters on the Kabbalah and Anthroposophy which flew, partly literally, into *Neoism, Plagiarism & Praxis*) and more substantially by the person behind the London Psychogeographical Association. It is Home's misfortune that the *LPA Newsletter* appears simultaneously with his Neoist Alliance pamphlets and manages to be so obviously better and wittier than the latter.

Ciao, Florian.

Letter 52: Florian Cramer to Stewart Home

[undated]

Dear Stewart,

Just a few points concerning 'history' I am firing off at you before I pass out or pass into the rest of the working week which, in true Groupe Absence fashion, never seems to get started. Far be it from me to demand 'correct historification', but whether it

might be your transcendental subjectivity tending to encode your spirit as the Hegelian objective, or not, this is my eleventh letter in this time of decreasing sperm cells.

The *Flying Cats* video was shot by Kiki Bonbon and Tristan Stéphane Renaud who then had an obsession with kicking cats in the street and poisoning food in grocery stores. So they were being invited to dinner by a friend who hated these obsessions and, since they knew this, they started to become paranoid suspecting her to have poisoned the dinner. (Caught in hypochondria, they both ended up at the emergency station of a hospital where they were found perfectly healthy.) However, and I wonder that nobody has informed you about that after 1988 – i.e. I am not wondering in fact since you were one of the few or even the only Neoist not being indifferent about 'history' – the *Flying Cats* video didn't show cats being thrown down from a tower block, but Kiki Bonbon and Tristan Renaud cutting the throats of a bunch of kittens (in an apartment room), and according to Tristan, it was mainly a situation to explore the actor's behavioural limits, i.e. repulsion of themselves, and insofar perhaps 'existentialist'.

However, the 'point' of Neoism as it emerged around 1980 in Montreal seemed to be rather a Hungarian weirdo who could just speak a few rags of English and French going from café to café and claiming to be an immortal leader and pop star, which a group of young people found hilarious enough to join him, maybe in a similar way as the Berlin dadaists called Johannes Baader their 'supreme'. Since Neoism was, above all, a collaborative exchange between Montreal and Baltimore for a couple of years, I suspect a superficial Situationist influence through some Krononauts who had heard of the SI. What you call 'Post-Neoism' existed at least as two phenomena, the one being the Montreal activities from the late '80s to the present, mainly involving the Society of Conserving the Present ('Society of Conserving the Future', as you erroneously called it, would miss the pun and the point of its activities) with Jean Dubé (who left it to found the Groupe Absence), Philippe Côté, a philosophy graduate, and Alain Bergeron, a computer programmer. The .(SCP) is, even more than the Groupe Absence, heavily based on a reception of recent 'theory'; both display a very francophone intellectual humour. Closely associated to both .(SCP) and GA are Alain Napoléon Moffat who works at the Canadian section of Gallimard publishers and was temporarily alienated from the earlier Neoist group due to his close ties to gay bohemia, and Jean-Luc Bonspiel (Kiki Bonbon) who might have ended up as a journalist. Although it's chiefly a light novel about a computer bulletin board system, Dubé's *Vouloir de L'art* seems to be a key text, in which Renaud, Bonspiel, Alan Lord, Bergeron and Moffat appear in dedications, fictionalised as characters or in quotations from unpublished manuscripts: ('Ce n'est pas cet échange des principaux remèdes qui nous rendra sensibles aux forces en présence. C'est l'.')

Neoism as its perpetual procrastination –

Cramer.

Letter 53: Stewart Home to Marshall Anderson

29/5/96

Dear Marshall,

Like you, I can't believe May is over. I've been doing more work for *The Big Issue*. The latest is one on porn stars who move into the art world. This week I got my first cover feature, I enclose the article on Glop Art. I had a good bank holiday weekend with Carolyn. We met in Colchester, I'd never been there before. The town was bigger than I imagined. Saw the castle, the Dutch quarter and all the other things you'd expect. We then headed for Manningtree. As we got into the tiny town on the Stour, we saw a hoarding advertising a gig by a band whose frontman used to work with Carolyn. So we popped into the pub to say hello to her friend. The Stour looked fantastic, even though it was low tide. We wandered around the town and the light was incredible. We cut up from the shops around the back of town to neighbouring Mistley. We saw the famous and very strange Mistley Towers. Mistley Place Park was closed, but we climbed over a fence and found what remains of a maze planted in the 1870s. Foolishly, it was planted with oak trees in it, which grew too big and the roots eventually destroyed the maze! On Sunday we drove up to Aldeburgh, going to a huge car boot sale where I bought a bicycle for £15. We went into town and walked along the coast as far as the Martello Tower. Then we got some coffee. After that we walked back through the town to the Moot Hall. The shops were all open, including the charity shop, but we didn't find anything we wanted to buy. We went up to the Crown in Middleton in the evening, but left pretty sharply once we realised it had been invaded by folkies. So we spent more time wandering around the village and surrounding countryside in the dark. On the bank holiday Monday we headed for Southwold, and took in the village fete. The weather was a bit blustery, so we didn't spend much time on the beach. Again, all the shops were open, including the charity shop, so we just wandered around town and amused ourselves at the fete stalls [. . .]

Ciao, Stewart.

Letter 54: Florian Cramer to Stewart Home

[undated]

Dear Stewart,

Far be it from me to be obsessed with 'correct historification', all the more as I only could, if at all, be called a tertiary, quartary, quintary source, or even lower. But I tend to doubt a more than superficial relatedness of Neoasm to the concept of 'avant-garde'. My own obsession with 'tradition' and 'speculation' is different from 'anti-avant-garde'. At this point I agree with tENT who said that for him, Neoasm was never concerned with 'avant-garde', as I don't agree with him at others. Istvan Kantor would

say the opposite, Graf Haufen and Sevol, too. I would have said the opposite in 1989 when I came to Glasgow and was obsessed with modernism. And so on.

There was manifest situationist influence on 'CoAccident', the superstructure of both BaltiMedia/the Krononauts and the grant-funded 'art professional' Merzaum collective whose members were, among others, Kirby Malone, Marshall Reese, cris cheek, Lee Warren (author of 'The Grooming Tool' in John Berndt's *Smile* issue 6, vol. 2) and Chris Mason, founder of Widemouth Tapes which tENT turned into WiDÉMOuth Tapes. In 1980, the Maryland arts magazine *Aura* portrayed both factions of CoAccident in 'Mad Science & Folk Math' (*Aura*, vol. 3, no. 1, pgs. 12-13) mentioning 'a number of projects, including Crab-Feast, Sleep Deprivation School, & Society of Spectacle' (page 12). [. . .]

My reason to refer to *Flying Cats* again was not the passage in *The Assault on Culture* whose carefulness I had well in mind, but the interview from which I gathered that even after five years, nobody had disclaimed it. In 'fact', I don't care much about the supposed facts and find it hilarious how the myth gets perpetuated again and again, like in those collective anonymous anti-Stewart Home letters.

If the term 'Post-Neoasm' makes sense – should it? – as third generation oxymoral cheapening – , it might, if synonymous with 'Post-Anti-Istvanism', fit the .(SCP) and the Groupe Absence as well, both assembling former Neoasts who got sick of Istvan and Neoasm, shifting from 'existential' to 'ironic' grammars. However, since their activities are geographically and lingually limited in the .(SCP)'s case, separated from networking channels, or, like the Groupe Absence, hardly involving activity at all, they surely cannot be considered 'mainstream'. Otherwise, I seem neither qualified to judge nor much concerned about 'significance' [. . .]

Yours, Cramer.

Letter 55: Stewart Home to Marica Spagnesis

22/6/96

Dear Marica,

Unfortunately the way anglo-american publishing works, it is very difficult for anyone working against the established literary conventions of good taste and traditional morality to get published. You can have distasteful things happen in fiction, as long as you believe in all the old fables about 'good' and 'evil' – this ridiculous schema is promoted by non-entities like Will Self, who the literary establishment absurdly promote as being somehow 'rebellious'. According to publications like the *NME*, Martin Millar and myself are England's two chief punk novelists. I know Martin, he's a nice enough guy, but our writing is like chalk and cheese [. . .] Martin doesn't share my interest in experimentation and deliberate transgression of notions of good taste. I assume you're familiar with Irvine Welsh, whose work isn't to my personal taste, but

is at least pushing in a healthy direction. I do have a problem with the way Welsh is portrayed as 'authentic', a ridiculous notion. Why don't people 'get real' and embrace the 'inauthentic'? A book just published and creating quite a lot of interest is *The Football Factory* by John King, who was going to punk gigs in the late-seventies and used to edit the fanzine *Two Sevens*. *Gobbing, Pogoing and Gratuitous Bad Language: An Anthology of Punk Rock Short Stories* edited by Robert Dellar (Spare Change Books, Box 26, 136 Kingsland High Street, Hackney, London E8 7SN, UK, price £6.95 but add some extra postage if you're ordering from Italy) is very mixed but I'd imagine you'd want to get hold of it. The piece by editor Robert Dellar is very good, and I have copies of some of his unpublished stuff, which with a bit of polishing will become real gems. You may also be interested in people like Gordon Legge, who had a book of short stories and a novel called *The Shoe* published by Polygon. He writes about punk rock in suburban Scotland.

As for the US, you must be familiar with people like Lydia Lunch and Henry Rollins. Beyond *Six Pack*, I'm not a fan of Black Flag but I have to give Rollins credit for being a good performer. However, I think his prose falls dead from the page. US 'punk' musicians fit into a well established underground scene and even for the UK, I'm not sure how much sense it makes to separate a punk literature off from a more general transgressive literature. I certainly feel more at home with American writers like Lynne Tillman and Dennis Cooper, although there are a few British writers who are worth reading. If you decide to do your dissertation on punk literature, I'll try and help. [. . .]

Ciao, Stewart.

Letter 56: Stewart Home to Florian Cramer

7/7/96

Dear Florian,

I have just been editing together the letters you sent on disk with some of my own to various personages. I think the result does you a great deal of credit. I have had to select and edit and I'm sure the outcome would have been very different if you had been given the material to work upon. The whole thing is spun around our correspondence of the past year. What I've tended to edit out of this is the copious details of where on the Net you were intending to place the various electronic versions of the texts I'd sent you. Toward the end, I've 'cheated' things a little. Having made extensive use of your e-mail message to Zion Train in my letter to you of 19 May 1996 (after being provided with a copy of it by the band), I thought your hilarious reworking of it into a critique of yourself by way of reply, was a little too repetitious for casual readers. Therefore, the compendium concludes with a couple of your earlier undated letters about Montreal Neoism. The selection of my correspondence to other parties is hardly representative either. For example, there isn't a single line to Jussi Ahokas, my Finnish translator, simply because the extensive correspondence with him is off on

another tangent completely – a combination of translation queries and stuff about punk rock. Likewise, my snail mail interactions with Alastair Dickson just didn't gel with the other stuff I've collected together in *The House of Nine Squares*. The 238 letters I've preserved since last August really don't merit publication in their entirety, or at least not in my opinion. It might have been nice to include some of the letters I've received from Luther Blissett and others, but I didn't have the patience to type them up. Despite these limitations, I think the result is 'illuminating' and in many ways I'd consider it the best piece of 'Neoist' text with which I can claim an involvement.

I thought both of your recent mailings were great fun. The open letter to tENTATIVELY was excellent. Whether or not it was intended as a defence of my position in the light of various ridiculous attacks made by morons who have no understanding of Neoism, I certainly feel it will have that effect. I greatly appreciate your support and solidarity. Having delivered this devastating blow to various external critics, I was delighted that you should follow it with the 'Clifford Brown' text, a kind of best of selection of your criticisms. Needless to say, the effect is very different to that attained when these morsels of text are viewed in their previous context of an exchange of letters.

Ciao, Stewart.

Afterword

'Neoism is sound where there is sound, any vacuum imagined'
The Neoism Machine

Hello and farewell to *The House of Nine Squares*, the international book of language games and total freedom. It may be difficult for the casual reader to understand or appreciate *The House of Nine Squares* as an allegorical edifice because *The House of Nine Squares* itself is the vehicle of its understanding. When it is no longer possible to differentiate between the signs and the things, the structure of things must begin to repair itself. *The House of Nine Squares* is here to fix these things once and for all.

A chief concern of *The House of Nine Squares* is to rewrite its readers into players. This is to be gradually achieved. First, *The House of Nine Squares* denies there is a game. Second, it hides the rules from those involved. Third, it gives them all penalties and no wins. Fourth, it removes all goals, enforces their playing, inhibits their enjoying. Fifth, it makes them look like players, but forbids them playing. To make a reader remain a piece in the game, it permits him to associate only with pieces and denies the existence of players.

Imagine a house. Six walls. A house, no door, no window. A reader inside that house. The house is 20 feet across and 20 feet high and 20 feet wide. But the reader's diameter is only 19 feet. His awareness is only 19 feet. Does he see the walls? No! *The House of Nine Squares* makes him think he is a one-lifetimer, and his awareness goes down to 18 feet. And when it goes down to 18 feet, *The House of Nine Squares* moves its walls in to 19 feet. When *The House of Nine Squares* gets him down to the size of a fist, its walls are the size of stretched out arms, and everything is nicely repaired. And if anyone jumps out of the line, we got lobotomy, epistemological trepidation, shock treatment, Siberia – whatever you want, baby, it's there.

So be on your guard! Read *The House of Nine Squares*. Take it home. Don't be ignorant. *The House of Nine Squares* is compassionate, and it is cruel. Be on your guard! Don't hate its obedience and don't love its self-control. Don't dismiss it in its weakness, and don't be afraid of its power. Why do you despise its fear and curse its pride? It lives in fears and strengthens in trembling. *The House of Nine Squares* is stupid and it is wise. *The House of Nine Squares* will be silent among the silent, and it will appear and speak. Why then have you dismissed it?

The House of Nine Squares appears when you are away, and it hides when you appear. Take it home to places which are ugly and in ruin. Out of shame, take it home and scatter its members shamelessly. Approach it and turn away. *The House of Nine Squares* is the reading that is attainable to anything; it is the speech that cannot be grasped.

If you want to understand *The House of Nine Squares*, differentiate. If you want to know what it's all about, understand its philosophy. Understand its technical application, and regard *The House of Nine Squares* in its own words, and regard its writers (Stewart Home and Florian Cramer). Conceptual understanding is of

importance here. Not everything written in *The House of Nine Squares* is of equal value. *The House of Nine Squares* has its own opinion, and it has a right to keep its own opinion. And boy, it's got some wild opinions. You oughta hear them sometime. But that's a different thing . . . a different thing . . . and you can tell very easily when it swings over into its opinion, when it starts rambling about this or that. Take it as amusing, but it doesn't have anything really to do with *The House of Nine Squares*. *The House of Nine Squares* itself is cleaner than a wolf's tooth. There are a lot of wolves' teeth out there and they aren't too clean.

Neoistically[1], *The House of Nine Squares* is perfect, perhaps the only perfection in man that has superseded nature. By differentiating a little bit, one can get the true intention of what *The House of Nine Squares* tries to accomplish. It really wants to help mankind and at last we owe it great respect for that.

FLORIAN CRAMER, Berlin January 1997.

1. 'Neoism' simply means that what is done in its name is both new and yet part of a discourse. It does not imply that it is original. In this sense, Neoism coincides 'past', 'present' and 'future', rendering them pointless. Neoists find any obsession with the concept of freedom futile. Neoism is not a means to freedom, but seeks to prescribe structural sets to provide the discipline of a combinatorics within the lives of Neoists, with perpetual permutations. The purpose of Neoism is to construct mnemonic structures on the mental plane and so experimentally invigorate the notion of culture. Of all values and norms we believe the value of tradition is the greatest; this is the one we try hardest to reinforce.

In a Neoist view, the world is not things colliding in space, but a disjointed row of unconnected phenomena. Neoism does not conceive of the spatial as lasting in time. Since each state is irreducible, the mere act of giving it a name implies falsification. The paradox however is that names and epistemologies exist in Neoism, in countless numbers. There are Neoists who consider a certain pain, an overly yellow white, a temperature, a certain tone the only reality. Other Neoists perceive all people having sex as the same being, and all people memorising a line of Shakespeare as Shakespeare. Another group has reached the point of denying time. It reasons that the present is undefined, that the future has no reality than as present hope, that the past is no more than present memory. Yet another group has it that the history of the universe is the handwriting produced by a minor god in order to communicate with a demon; that the world is an emblem whose subscription is fragmented, where only that which happens every three hundredth night is true. Another believes that while we are asleep here, we are awake somewhere else, so that everyone is two. Books are rarely signed, and the notion of plagiarism does not exist.

Neoism is, most generally speaking, a prefix and a suffix without a middle. Stewart Home wrote that Neoism was invented in the year 1346, by one Wolfgang von Cantsin. He joined Neoism in 1984 when, if we believe his history, it was already about to 'dissolve'. But what else was Neoism about than dissolving? Neoists even claim that 'Neoism' never existed and is a mere invention of its enemies, Anti-Neoists. Since the Neoists want to create a

situation in which a definition of Neoism should make no sense, Stewart Home's attempt to write off Neoism by historicising it proves how well he has learnt his Neoist lesson. Obsessed with reality adjustment and mad science, the Neoists themselves produced nothing but manipulations of their own and other histories.

In his introduction to this book, Stewart Home quotes me saying that Neoist names like Monty Cantsin, Akademgorod, Neoism are looked upon not as arbitrary, but as self-contained signs so that everything done with these signs immediately affects what they represent. While we agree on this point, our views of the history of Neoism differ. Neoism, as I see it, was at first probably nothing but a collection of private ironies. They were elaborated in allegories, hieroglyphs and fables whose hidden meaning only insiders could decode. Later, this hidden meaning got lost, and the signs were taken for their signified. Since the signs obviously had to mean something, Neoists had to reinvent their meaning. The remotest analogies between signs and things were taken until Neoism became an art of concordant discord, a self-refuting perpetuum mobile. Its great promise to willingly affect matter, space and time, the sublime solemnity of its proclamations had an extraordinary impact on those unenlightened by intellectual thoroughness.

Neoists established the name Monty Cantsin to live and explore the paradox of a persona that is one and multiple. They research the aporias of a subjectivity which, as 'both/and' and 'neither/nor', attempts to render its own dialectical base invalid. Neoists prefer tradition and speculation to avant-garde. They declare Neoism a movement, which, just like Stewart Home, creates the illusion of a movement called Neoism.

Guide for the Perplexed

ANDERSON, MARSHALL: Guardian of the PETE HOROBIN archive, artist and arts journalist, who relentlessly wanders the Scottish Highlands. Sprang fully formed into this world at the age of forty in 1990. See also PETE HOROBIN.

AYERS, NIGEL: Musician and Fortean researcher now based in Cornwall. His 'group' Nocturnal Emissions have been thrilling devotees of experimental sounds for more than a decade.

BARONI, VITTORE: Veteran Italian alternative artist, musician and rock journalist, now heavily involved in the LUTHER BLISSETT project. AAA, BARONI'S independent publishing house, issued a translation of HOME'S *Assault on Culture*.

BERNDT, JOHN: Boy wonder of Neoism who joined the movement in late 1984. These days BERNDT remains an uncompromising player/composer of experimental music, student of the 'meta-technology of Henry Flynt' and is a self-made businessman.

BLISSETT, LUTHER: Multiple identity of mysterious mid-nineties origins. HOME'S correspondent who uses this name is a sharp witted prankster living in Bologna, Italy.

CANTSIN, MONTY: Multiple identity popular among members of the Neoist Network and Webmaster of *Neoism Online* <http://www.neoism.org>.

cONVENIENCE, tENTATIVELY a: Leading first generation Neoist and self-described 'Mad Scientist / d-composer / Sound Thinker / Thought Collector / Psychopathfinder & Jack-Off-Of-All-Trades'. Since tENTATIVELY left his home town of Baltimore in the mid-nineties, he has wandered across Europe and North America.

COTTRELL, ROGER: A lost soul.

CRAMER, FLORIAN: Born in 1969. 'I am not a Neoist. Neoists never use that term. Neither am I interested in language games around my person.'

DICKINSON, BOB: Manchester Area Psychogeographic activist.

DICKSON, ALASTAIR: Belongs to the Scottish section of the collective producing the radical magazine *Here & Now*. Subscriber to the Virginia Avant-Garde List, friend of HOME and MARSHALL ANDERSON.

DUNN, GRAHAM: Bookseller.

DUNN, LLOYD: Iowa based artist, publisher and musician. A member of the Tape-beatles and editor of *Retrofuturism* and *PhotoStatic*, he played a key role in propagating the 1990 Art Strike.

EDEN, JOHN: Former London Temple Ov Psychic Youth activist, now involved with Turbulence and the Association of Autonomous Astronauts.

ESSEX, RICHARD: London Psychogeographical Association activist.

FLY: Musician and artist, Canadian national based in New York, she plays with both God is My Co-Pilot and Zero Content. Met HOME at the Association of Autonomous Astronauts launch event in Windsor Great Park.

GRAHAM, BARRY: Scottish novelist now based in Arizona. His books include *Of Darkness and Light* and *The Book of Man*, the latter being a highly fictionalised and parodic account of the strange life and death of Alexander Trocchi.

HAUFEN, GRAF: Berlin-based sleaze video and techno music tradesman and publisher. An active Neoist between 1985 and 1987, he organised the 64th Apartment Festival and compiled the outstanding anthology *Neoism Now* (still available from haufen@berlin.snafu.de).

HOME, STEWART: Novelist and multiple enigma.

HOROBIN, PETE: Born in London in 1949 but moved to Scotland during his childhood where he remained, apart from six months spent in London during 1984, until at least 1990. Leading member of the Neoist Network and Data Artist who recorded his own life in incredible detail. Mysteriously disappeared in 1990 at the age of forty. See also MARSHALL ANDERSON.

LEAGUE OF EGOISTS: Dutch collective seeking to integrate individualist and collectivist political and cultural perspectives.

MULLINS, PATRICK: Bureau of Unitary Cosmopolitanism activist.

OGG, KIRSTY: Member of the collective running Transmission Gallery, Glasgow.

O'RIORDAN, SHANE M: Active on the Vancouver redskin, scooter and poetry scenes, SHANE introduced herself to HOME as he was purchasing a secondhand copy of a Richard Gombin paperback in a Canadian bookstore in 1995.

PADIN, CLEMENTE: A prominent performance, video and mail artist from Montevideo, Uruguay. He has been jailed for what in other parts of the world might be considered quite innocuous activities.

PERKINS, STEPHEN: British born but US based underground artist. He played a key role in the organisation of the 1990 Art Strike.

PITCHON, AVI: Israeli artist and journalist.

RUMNEY, RALPH: Founder member of the Situationist International. British born, he currently resides in France.

SINCLAIR, IAIN: London based novelist, poet and psychogeographical explorer. His works include *Lud Heat*, *Suicide Bridge*, *White Chappell Scarlet Tracings*, *Down River* and *Radon Daughters*. HOME makes a cameo appearance in the latter and is featured in *Lights Out for the Territory*, SINCLAIR'S most recent book.

SPAGNESIS, MARICA: Literature student at Rome University.

TILLMAN, LYNNE: Simultaneously the most witty and unapologetically intellectual contemporary New York novelist. Her works include *Haunted Houses*, *Cast in Doubt* and *Motion Sickness*. HOME makes a cameo appearance in the latter.

new publication

Off Ardglas by Rob MacKenzie

"Rob MacKenzie is an analytical artist. His vibrant language expresses the impact of love and landscape on his alert senses. . . . He probes regrets and opportunities; departures; the rural sprays of Lewis; the urban clashes of Cambridge, Edinburgh, Stornoway. But he is fundamentally positive in his restless linguistic energy. At times that verve seems out of control but better that—surely—than tame verse."

<div align="right">IAN STEPHEN</div>

ISBN 0 9521256 5 x £5.95

published last year

Idir Eatortha & Making Tents by Catherine Walsh

"The poem has a tension of opposites: stillness/movement, dark/light, noise/silence, hell/wonder. . . . Another poet to read and re-read."

<div align="right">*Poetry Quarterly Review* Winter 1996</div>

"Pushing it around like acrylic or gouache, she's working with the history of her language. . . . But we aren't left marooned in the occasional; we're in the (manu)factory of delight, getting a glimpse of how consciousness shapes itself. Don't miss it."

<div align="right">HARRY GILONIS</div>

ISBN 0 9521256 4 1 £5.50

Rousseau and the Wicked by Bill Griffiths

"With an open syntax, and a playfulness with language which belies its force, he remains one of the most challenging, oppositional poets of his generation, and one who steadfastly deals with the conflicts of his (our) world. . . . In *Rousseau and the Wicked* he offers new readers a chance to experience a wide range of new takes on old expectations. Take it: your roots may never be the same again."

<div align="right">RICHARD CADDEL</div>

ISBN 0 9521256 3 3 £5.50

all orders and enquiries please to—
> INVISIBLE BOOKS
> BM INVISIBLE
> LONDON WC1N 3XX

Individual customers post free in UK. Please make cheques payable to P Holman and B Penney. Trade terms are available on application.

also available

from The Book of Legends by Jane Wodening
"You might look on Jane Wodening's *from The Book of Legends* as the charming antitype of those monster biographies we have come to expect nowadays. . . . You can read the book in half an hour and you have the saliences of these lives, two of them famous people, Joseph Cornell and Charles Olson, the third the story of the less famous—at any rate on this side of the Atlantic—Maya Deren, a voodoo dancer and priestess."

CHARLES TOMLINSON *PN Review*

ISBN 0 9521256 0 9 £4.95

Carp and Rubato by Anthony Barnett
"The writing reveals a complex, self-reflexive dimension in which the text addresses, or better, enacts, what it is for the poet to recognise—in the life specific to the poetic style—the truths of experience. . . . There is a distinction here that English literary culture can ill-afford to ignore."

MICHAEL GRANT *PN Review*

ISBN 0 9521256 2 5 £5.95

The Invisible Reader
an anthology featuring the work of Anthony Barnett, John M Bennett, John Bevis, Richard Caddel, Bill Culbert, Ade Deaville, David Dellafiora, Patrick Eyres, Ian Hamilton Finlay, Harry Gilonis, Bill Griffiths, Stewart Home, Ronald Johnson, Rob MacKenzie, Friederike Mayröcker (translated by Rosmarie Waldrop), Andrew Norris, Woodrow Phoenix, peter plate, Lynne Tillman, Catherine Walsh, Aaron Williamson.
ISBN 0 9521256 1 7 £7.95

due 1998

Luna Bisonte
a selection drawn from the pages of *Lost & Found Times*, the Ohio-based magazine published by Luna Bisonte Prods which has operated at the raw edges of language poetry, mail art and much else since 1975. Texts and graphics of extreme rigour rub up against those gleefully exploring niches to which Surrealism pointed the way. Featuring work by Dr. Al Ackerman, John M Bennett, Sheila E Murphy, Susan Smith Nash, Richard Kostelanetz and many more.
ISBN 0 9521256 8 4

The Ghost Pirates by William Hope Hodgson
What happens when you set sail in a shunned ship, whose last crew deserted in mysterious circumstances? Readers of Hodgson's classic short story *The Voice in the Night* will recognise the eerie seascape but even they will not be quite prepared for the horror that emerges from beneath the waves. A superb and long unavailable novel from the author of *The House on the Borderland* and *The Night Land*.
ISBN 0 9521256 6 8